DEATH BY HOGARTH

DEATH BY *Hogarth*

ELIZABETH KATHLEEN MITCHELL

HARVARD UNIVERSITY ART MUSEUMS
CAMBRIDGE MASSACHUSETTS

Death by Hogarth is the catalogue of an exhibition organized by the Harvard University Art Museums, Cambridge, Massachusetts, 8 May–18 July 1999.

The exhibition and publication are supported by the Harvard University Art Museums' John M. Rosenfield Teaching Exhibition Fund.

Library of Congress Cataloging-in-Publication Data

Mitchell, Elizabeth Kathleen, 1971–
 Death by Hogarth / Elizabeth Kathleen Mitchell.
 p. cm.
 Catalog of an exhibition held at the Harvard University Art Museums,
 Cambridge, Mass., May 8–July 18, 1999.
 Includes bibliographical references and index.
 ISBN 1-891771-08-6 (alk. paper)
 1. Hogarth, William, 1697–1764 Exhibitions. 2. Hogarth, William, 1697–1764—Political and social
views Exhibitions. 3. Executions and executioners in art Exhibitions. 4. London (England)—Social life
and customs—18th century Exhibitions. I. Hogarth, William, 1697–1764. II. Harvard University.
Art Museums. III. Title.
NE642.H6A4 1999
769.92—dc21 99-27875
 CIP

Produced by the Publications Department, Harvard University Art Museums
Evelyn Rosenthal, manager of publications

Editors: Jennifer Barber, Evelyn Rosenthal
Designer: Eleanor Bradshaw
Printer: MacDonald & Evans

Printed in the United States on acid-free paper

COVER ILLUSTRATION:

William Hogarth, *The Idle 'Prentice Executed at Tyburn*, 1747 (cat. 7)

CONTENTS

FOREWORD

Attending the scene of a violent punishment or death by execution would today be considered a punishment in itself. But in eighteenth-century London, such scenes had a certain public appeal. As Elizabeth Mitchell demonstrates in her thoughtful and well-researched catalogue essay, public executions in the age of Hogarth were akin to theatrical performances. They attracted huge crowds of men and women from all strata of Georgian society, and encouraged vocal and gestural responses. At the gallows, vendors sold pamphlets, broadsides, food, and drink, while petty criminals and prostitutes circulated through the crowd plying their wares and trades.

In his printed oeuvre Hogarth often depicted scenes of execution as well as of the theatre, including both audience and actors. His flair for capturing the public's response to performance—especially to a dramatic performance like a public execution or the staging of an exaggerated moral tale—is evident in the wild expressions and dramatic gestures of the figures he depicted. These contortions of face and body often propel his visual narratives from one engraved plate to another, as, for example, in his *Marriage à la Mode* and *The Four Stages of Cruelty*, or within a single plate, as in *Gin Lane*. No one was a better storyteller in pictorial form than Hogarth. He was Georgian England's most popular printmaker, the visual equivalent of Laurence Sterne.

We are very pleased to present *Death by Hogarth*. It is the work of Elizabeth Mitchell, the 1997–99 Lynn and Philip A. Straus Intern in the Fogg Museum's Department of Prints, and was undertaken with the critical assistance of Marjorie Cohn, the Fogg's Carl A. Weyerhaeuser Curator of Prints. The exhibition includes prints, books, and maps from the Fogg's collections as well as those of Harvard's Houghton Library and Map Collection. But the largest group of works in the exhibition came from the collection of our longtime friends Suzanne and Gerald Labiner.

Sue and Gerry have been good friends of the Art Museums for almost fifteen years. Their immediate, positive response to our requests for copious loans is typical of their generosity in support of students and scholarship. They are devoted to the art and age of Hogarth, and they want to share their enthusiasm and knowledge with students and scholars in every way. We are grateful to them for their help with this exhibition; it could not have happened without their great commitment to Harvard, its students, and to the Art Museums' mission of teaching and research.

JAMES CUNO

Elizabeth and John Moors Cabot Director

ACKNOWLEDGMENTS

First and foremost I would like to thank Lynn and Philip A. Straus for furnishing the internship through which this exhibition was realized. I owe a special debt of gratitude to Suzanne and Gerald Labiner for allowing me to study their collection of Hogarth prints and lending the works for this exhibition. The direction, education, and editorial expertise I received from Marjorie B. Cohn, Carl A. Weyerhaeuser Curator of Prints, is invaluable, and I am appreciative to her beyond measure. I am truly grateful to the anonymous reader of a draft of my manuscript, who offered constructively provocative criticism. The encouragement and vision of James Cuno provided great inspiration in the formation of this exhibition.

Appreciation is due to Peter Nisbet and my fellow interns at the Fogg Museum for their participation in a seminar that encouraged lively discussion of museum practices and thoughtful input on my research. I am grateful to the departments of Conservation, Exhibitions, and Publications for the tremendous work they put toward this exhibition and catalogue. The Houghton Library, Harvard Law Library, Harvard Map Collection, and Francis A. Countway Library of Medicine provided generous access to materials crucial to my understanding of the social context that fed Hogarth's imagination. The cheer and support contributed by all members of the Mongan Center made this internship a rich and enlightening experience; the company of *mis amigos de la Casa*, Kevin Dacey, Edward Saywell, and Michael Dumas, has been a pleasure. My parents, Doris F. and Danny W. Mitchell, have advanced my work and studies through their confidence and love. Many authors shaped my perception of art within civic history and culture; in a broader context, I wish to recognize David Foster Wallace for prompting me to consider the role of diversion and entertainment in relation to my interest in the eighteenth century.

INTRODUCTION

ALTHOUGH IT MAY SEEM INCONGRUOUS FROM A TWENTIETH-CENTURY PERSPECTIVE, in early modern England public executions were as popular an amusement as pleasure gardens, fairs, and theater extravaganzas. Art, performance, and capital punishment blended irreverently in grisly castigation spectacles staged northwest of London at the three-sided gallows known as Tyburn. William Hogarth (1697–1764) created numerous print narratives with references to archetypal characters, contemporary criminal culture, and the elaborate and emotionally overwrought rituals that accompanied executions. A connection between the visual drama of an execution and didactic art was made during Hogarth's lifetime; a slang expression described death by hanging as "to dangle in the sheriff's picture frame."[1] Accused criminals were executed at many established and improvised sites throughout England, but Tyburn, called Tibourne or the Elms in records that date its origins to the late twelfth century, was synonymous with hanging during the eighteenth century.[2] Given Hogarth's interest in contemporary manners and urban life, it is no surprise that he peppered his iconography with references to crime and execution.

Peter Linebaugh has already demonstrated that the double usage of the term *capital*, to indicate both profit and punishment, is particularly pointed in the context of eighteenth-century England.[3] Even after the Glorious Revolution of 1688 and its dissolution of the absolute monarchy, crime was still legally perceived as a violation against the king and, to a lesser degree, an offense against the individuals of the community. The notorious legal statutes known as the Bloody Code (1688–1815) designated hundreds of serious and minor trespasses against property as punishable exclusively by death. Lawmakers developed the Bloody Code in response to industrial and mercantile growth and for the maintenance of property; this second category included a man's dependent female relatives, his land, and his possessions.[4] For example, the 1715 Riot Act was used to subdue not just political protesters but also laborers who vandalized machines and destroyed goods in their protest of low wages or the importation of goods that infringed on their livelihood.[5]

Justice and civil harmony were of great concern to the citizens of London, and execution was historically significant to the maintenance of social order. Execution policy persisted because lawmakers agreed with Anthony Ashley Cooper (1671–1713), the third earl of Shaftesbury, who stated that the character of England's

common classes would benefit from exposure to "such a rectifying Object as the Gallows."[6] Hogarth illustrated that people of all classes perpetrate acts of deviance. It is also important to note that Hogarth's prints do not compose a sympathetic agenda against capital punishment as much as they present execution as one of the many unfortunate worldly ends earned by a life of dishonesty.[7] Other creative individuals reacted against the harsh legal environment by romanticizing insurgency and showing a sympathetic fascination with the condemned criminal in chapbooks, plays, and broadsides. Samuel Johnson sanctioned a threefold understanding of the word *execution* in the 1755 edition of his *Dictionary of the English Language*. Johnson, an acquaintance of Hogarth, defined the verb *to execute* (and its noun derivative *execution*) as performance, as death by official order, and as the process of following through on what is planned or determined.[8] All of these meanings tangle and overlap in Hogarth's narrative prints.

The following excerpt from Johnson's dictionary further elaborates these definitions.

To E'XECUTE. *v. a.* [*exequor,* Latin.]
1. To perform; to practice.
 Against all the gods of Egypt I will *execute* judgement. *Ex*.
 He casts into the balance the promise of a reward to such as should *execute,* and of punishment to such as should neglect their commission. *South's Sermons*.
2. To put in act; to do what is planned or determined.
 Men may not devise laws, but are bonded for ever to use and *execute* those which God hath delivered. *Hooker, b.iii,f.7*.
 The government here is so regularly disposed, that it almost *executes* itself. *Swift*.
3. To put to death according to form of justice; to punish capitally.
 Sir William Bermingham was *executed* for treason. *Davies*.
 O Tyburn, cou'dst thou reason and dispute,
 Cou'dst thou but judge as well as *execute,*
 How often wou'dst thou change the felon's doom,
 And truss some stern chief justice in his room! *Dryden*.

EXECUTION. *n. f.* [from *execute*.]
1. Performance; practice.
 When things are come to the *execution,* there is no secrecy comprable to celerity. *Bacon's Essays*.
 I like thy counsel; and how well I like it,
 The *execution* of it shall make known. *Shakespeare*.
2. The last act of the law in civil causes, by which possession is given of body or goods.
 Sir Richard was committed to the Fleet in *execution* for the whole six thousand pounds. *Clarendon, b.viii*.
3. Capital punishment; death inflicted by forms of law.
 I have seen,

When, after *execution,* judgement hath
Repented o'er his doom. *Shakes. Measure for Measure.*
Laws support those crimes they checkt before,
And *executions* now affright no more. *Creech's Manilius.*

4. Destruction: slaughter
Brave Macbeth, with his brandish'd steel, which smok'd with bloody *execution*, Carv'd out his passage. *Shakespeare's Macbeth.*
The *execution* had been too cruel, and far exceeding the bounds of ordinary hostility. *Hayward.*
When the tongue is the weapon, a man may strike where he cannot reach, and a word shall do *execution* both further and deeper than the mightiest blow. *South's Sermons.*[9]

The exhibition and this accompanying catalogue examine a specific slice of Hogarth's London through prints that address the meanings of execution as performance, officially ordered death, and fulfilling a predestined design, with an emphasis on images related to hanging.[10] The first section investigates images that expose the viscera of popular entertainment in their visual conflation of the theater and scaffold. This will establish a context for Hogarth's representations of conventional (read *male*) malefactors, my second area of investigation. Finally, I look at the iconography that specifically depicts females who took the deviant path and inevitably came to a bad end. An inclusive definition of execution allows for the incorporation of images and objects that illustrate the social context for execution rituals as well as the gender- and culturally specific perceptions of deviant behavior in Hogarth's time.

1. This slang is mentioned in Linebaugh 1975, 66.

2. Tyburn is mentioned by name in a quote from Dryden's poetry that appears in Johnson's definition for "to execute." Johnson 1755, 8M1v. See definition quoted below.

3. Linebaugh 1991, xv.

4. Naish 1991, 40–41.

5. See Gilmour 1992, 249–59, where he recounts industrial strikes and violent protests from the first half of the eighteenth century.

6. This quote appeared in Hay 1975, 19.

7. It would have been odd for Hogarth to speak out against capital punishment. This point is also raised in Bindman 1997, 139.

8. In Johnson 1755, 8M1v–8M2r.

9. Some of the demonstrative quotations have been omitted from this passage of definition from Johnson 1755, 8M1v–8M2r.

10. I will not survey all of Hogarth's morbid iconography; rather, I have chosen what are to me his most compelling references to deviance and execution culture. Others exist and will be briefly mentioned; some, as is the case with the 1725 *Hudibras* series and *The Bathos* of 1764, are not included in this exhibition and catalogue.

EXECUTION IN THE ROUND

William Hogarth achieved notoriety and commercial success as a printmaker by deftly integrating lively archetypes with symbols, locations, and dilemmas readily recognizable to people of all social stations. The evocative imagery he derived from the theater and the execution scaffold, two of the great stages for public spectacle in eighteenth-century England, figures significantly in his iconography. Like theatrical performances, executions were interactive occasions for the display of and struggle for control over both the physical and the political body. Both the theater and execution days attracted huge crowds of men and women across class groups, and the success of these events hinged on how well the performers fulfilled their roles. A spectacle was all the more exciting because it facilitated class mingling. Fascination with capital punishment generated a wealth of symbols to punctuate the prints Hogarth envisioned as "Modern Moral Subjects."

Hogarth frequented the theater from childhood on, and as an adult he belonged to an artistically inclined social circle that included actors, hack writers, and playwrights. He recognized the similarities between executions and plays, both in the arrangement of the physical space and the highly dramatic action, and successfully conflated them in images. His compositions, which are reminiscent of stage design, often include visible floors, ceilings, walls, and doorways that reveal secondary action. He furnished scenes with symbolic props and bawdy action performed by spirited figures, some bearing the likenesses of famous people. One small but complex detail embedded in the sixth plate of *Marriage à la Mode* (cat. 1) is the criminal broadside with an image of the Tyburn gallows in the upper register. This type of woodcut print embellished a scandalous story with the condemned criminal's origins, personality traits, and the nature of the crime of which he or she was accused. The text ended with a supposed confession and apology in which the felon renounced the crime and begged for mercy in the afterlife; thus, these prints were commonly known as "dying speeches."

The format for dying speeches evolved into a fairly standardized composition, as represented in the anonymous English eighteenth-century woodcut made for John Clarke, a gardener hanged for murder (cat. 2). A charnel-house symbol of death, in most cases a stylized human figure swinging from a gibbet or standing on a scaffold near a dangling noose, looms over the criminal's story and supposed last words. Gallows literature like the John Clarke broadside was generated rapidly and sold to the public before, during, or after the actual execution. The sale of such broadsides was a lucrative and competitive niche of the printing industry, so much

so that T. Parker and C. Corbett of Fleet Street, in their pamphlets made in the 1750s, claimed to be "the *only authorized* Printers of the Dying Speeches."[11]

Prints and printed material were peculiar currency in the eighteenth-century commerce among crime, memorialization, and death. Printmakers who aspired to be more than artisans sold mundane objects such as engraved funeral tickets and death announcements in order to support themselves. A historian of Tyburn, Alfred Marks, recorded the 1783 execution of William Wynne Ryland, an engraver turned forger who was so skilled that he was compared to Francesco Bartolozzi, a Florentine reproductive engraver popular with London collectors.[12] The publication of cheap woodcut gallows literature required only the minimal resources needed to carve and print from a woodblock. Sensational source material was generated daily in the streets of London and turned into accounts of felony escapades, ballads about the victims of horrible crimes, or sketchy portraits that catered to popular interest in the physiognomy of deviant types.

Word of a daring or remarkable crime spread quickly and the name of a criminal melded to his or her deed in the public mind; many criminals subsequently became folk heroes. In the eighteenth century, portraits of criminals were popular with print collectors, and Sir James Thornhill, Hogarth's mentor and father-in-law, set a precedent for high-quality criminal portraiture in his 1724 mezzotint of legendary thief and jailbreaker Jack Sheppard. Thornhill took Hogarth along when he sketched Sheppard in his cell. Hogarth repeated this tactic of visiting the doomed prisoner in jail for his portraits of Sarah Malcolm (cat. 41) and Simon Fraser Lovat (cat. 3). His 1746 etching of condemned Scottish rebel Lord Lovat is as opportunistic as any broadside, but with a sophisticated hand Hogarth integrated clever allusions to Lord Lovat's crimes into an image of the charismatic man. Other artists emphasized a criminal's image over his story, as in the drypoint portrait of the escaped criminal Hamet (cat. 4) by Thomas Worlidge (1700–1766). The delicate drypoint technique would not yield as many copies as a woodcut, etching, or engraving. This limitation, coupled with Worlidge's choice of a lesser-known felon and the omission of narrative details, may indicate that the artist targeted an audience curious about the pseudo-science of criminal physiognomy.

John Rocque included Tyburn gallows as a rural landmark in his massive project, begun in 1739, to survey urban London and its outlying areas. John Pine (1690–1756), a friend of Hogarth's, translated Rocque's work onto engraved plates (cat. 5). The map fixed the exact position of Tyburn beyond the city on the northeast border of Hyde Park, just west of the turnpike at the intersection of Tyburn Road and Tyburn Lane.[13] This is near where the Marble Arch stands today. At the site of the turnpike a metal plaque commemorating the dark legacy of Tyburn was installed in 1829. In the latter half of the eighteenth century, portable gallows were used more frequently, as depicted in the anonymous English eighteenth-century engraving of the execution of Lord Ferrers (cat. 6). Portable gallows were deliberately erected as close as possible to the scene of a crime, either in anticipation of a large crowd or to signify another layer of punishment.

The dramatic rituals of execution day were a natural contextual source for the theater and for artists like Hogarth to mine in recording current events and in shaping fictionalized visual narratives. Executions occurred eight or more times per year.[14] The progression to Tyburn, a ritual in which the public freely participated, consisted of a specific sequence of acts. Church bells pealed for five minutes to alert people of the

impending departure of the convicted felon(s) from a holding tank at Newgate, the Bridewell, or the Fleet Street prisons, all located near the Old Bailey courthouse.[15] Criminals—except for the rich, who were allowed to hire private carriages—were conveyed to Tyburn in a sledge or an exposed horse-drawn cart (in previous centuries the convicted party had been dragged behind the cart). The progression stopped at an established sequence of taverns along the approximately two-hour-long trek toward the Tyburn gallows. The condemned were supplied with as much drink as they cared to consume, to render them unable to struggle vigorously against the noose so they would die more quickly.

The atmosphere of the progression to the gallows ranged from solemn respect for the condemned to riotous outrage. The audience could be particularly unruly for the hanging of a loathed criminal, or of someone accused of an offense not regarded by the public as a real crime, such as smuggling.[16] In his 1725 pamphlet titled *An Enquiry into the Causes of the Frequent Executions at Tyburn,* Bernard Mandeville declared that the progression spectacle "from *Newgate* to *Tyburn,* is one continued Fair, for Whores and Rogues of the meaner Sort."[17] Toward the end of the century the tone of the progression had changed from somber compliance to rebellious rejection of the supposed didactic lesson imposed by execution. In 1783 the government, still reeling from the chaos incited by the Gordon Riots, abandoned the Tyburn site.[18] That year progressions were outlawed because of crowd insurgency, and the scaffold was relocated to a small courtyard behind the walls of Newgate Prison. This grasp for social control created a greater predicament: executions at Newgate drew larger and more unruly crowds than Tyburn had, and the madness occurred within the confines of London.[19]

At the gallows, vendors sold pamphlets, broadsides, fruit, and drink, while pickpockets and prostitutes circulated among the mob. The condemned were expected to dress well, present themselves civilly, and voice a repentant confession before being strung up. A person would hang until being declared dead; the length of time depended on the victim's strength and the skill of the executioner. Hours of torture or accidental decapitation were not impossible in the hands of an inept or flustered hangman.

Depending on public opinion of the criminal, the crowd at an execution could turn volatile, and so, to Hogarth, observation of the audience was as significant as the spectacle itself. Thus, he placed the wild crowd in the foreground of *The Idle 'Prentice Executed at Tyburn* (cat. 7) from his 1747 series *Industry and Idleness.* The hangman, one of the very few calm figures in the scene, lounges casually atop a carriage headed for the gallows. In a 1759 print titled *The Cockpit,* Hogarth outlined a gibbet on the shoulder of the jacket of a man who is seen only from the back. He also is a rare, calm figure who abstains from the havoc and gambling. In both images the face of the man designated as the hangman is obscured and his gestures are composed; Hogarth seems to ascribe an air of mystery and dignity to the office of executioner.

The theater, the setting for *The Laughing Audience* (cat. 8), also provided Hogarth the opportunity to observe candidly the spectacle that unfolded away from the stage. The spectators in the theater boxes and gallery are more subdued than the Tyburn mob, but the threat of violence exists in this print as well—fanlike arrangements of tall spikes fringe the barriers separating the audience from the orchestra pit. In their provision of morally charged entertainment, the domains of the actor and executioner shared a curious coexistence over the centuries. Politicians, monarchs, and Puritans strove to censor or ban shows featuring satirical

or profane content; conversely, the state endorsed public castigation as a demonstration of authority and a means for discouraging crime. In times of political instability the theater was closely monitored as a possible forum for the expression of subversive ideas; this perceived threat was taken extremely seriously. Such open, verbal ridicule was characterized by the eighteenth-century phrase "to do *execution*," which meant to viciously wound a person with sharp words.[20]

In his self-made role as social critic, Hogarth excavated small ironies buried under class differences and public decorum while he generated mirth or self-reflection. In the 1724 print *A Just View of the British Stage* (cat. 9), Hogarth humorously made the stage a scaffold and "did execution" to three Drury Lane theater managers whom he felt were guilty of poor programming. The image proposes to purge crass shows from the stage by executing those responsible for the theaters. The idea of capital punishment for art considered inferior was a satiric jest. Twenty-four years later Hogarth himself encountered danger and was arrested in France for sketching old garrisons. The structures seemed picturesque to him, but because they were military buildings he was charged on suspicion of espionage, a crime punishable by hanging. Although the case was dismissed, it crystallized the antagonism Hogarth felt thereafter toward the French.

In Hogarth's carefully constructed intersections among stereotypes of different social stock, the criminal character—whether rebellious, devious, or stupid in his actions—served as a bold antithesis to the conventional hero. In five paintings Hogarth illustrated the whole spectacle of John Gay's 1728 play *The Beggar's Opera,* including the audience as well as the actors. His vision of the play as a setting for a conversation piece—a painting that captures portraits in an informal and social setting—proved to be enduring. One scene (cat. 10) was engraved by William Blake (1757–1827) sixty years after Hogarth created his paintings. Hogarth's enthusiasm for theatrical imagery was integral to his achievement; he made use of a good story, suspense, and a just resolution in both his series and his single-frame narratives.

11. From the title page credit line of Taylor 1750.

12. Marks 1909, 266.

13. To translate into more recent nomenclature, the present Oxford Street was called Tyburn Road and Park Lane was known as Tyburn Lane. The name Tyburn was derived from a small stream and village nearby. Gomme 1909, 21 and 10.

14. Linebaugh 1991, 91.

15. Ibid., 75.

16. McLynn 1989, 14–15.

17. Mandeville 1725, 20.

18. The Gordon Riots occurred in London in June of 1730. The rebellion was instigated by a Protestant crowd in protest of a standing Act protecting Roman Catholics. The rioters opened and burned Newgate Prison.

19. Gatrell 1996, 604. England's last public hanging took place in 1868; capital punishment ended in 1964.

20. Johnson 1755, 8 M2r.

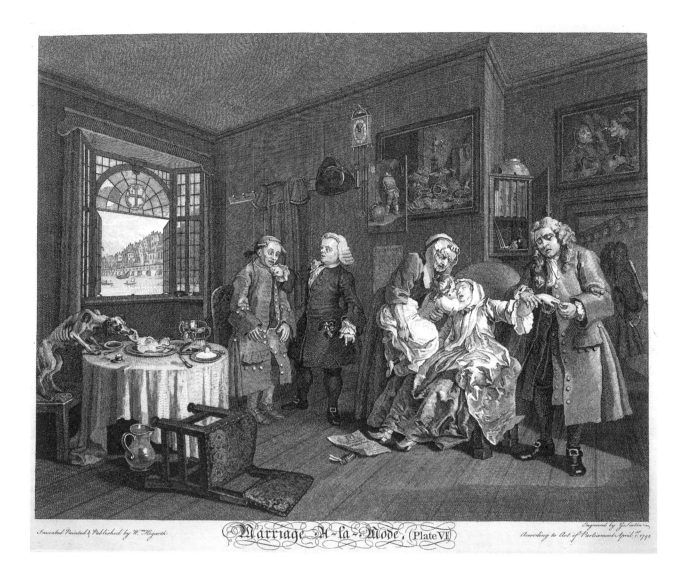

CATALOGUE 1

William Hogarth
English, 1697–1764

Marriage à la Mode

PLATE VI, 1745

Etching and engraving, 338 x 446 mm
P. 233, BM Sat. 2758 ii/iii
Collection of Suzanne and Gerald Labiner
TL36700.25

This is the sixth and final print from the *Marriage à la Mode* series, a visual narrative that chronicles the arranged marriage of two fictional characters, from the drawing up of the conjugal documents by the parents to the deaths of the doomed couple, the Earl and Countess Squanderfield. Hogarth included in this image a broadside containing a dying speech that brings new information to Countess Squanderfield and is a sign of how low the formerly grand couple has fallen. Like stage props in a melodrama, an overturned laudanum bottle rests at the countess's stiffened feet near the broadside announcing the hanging of "Counseller Silvertongue." Silvertongue, the lawyer who coordinated the Squanderfields' marriage contract, was the countess's lover and the earl's killer. The juxtaposition of the bottle and dying speech reveals that Countess Squanderfield committed suicide over the execution of her lover rather than her husband's murder. The broadside, the final blow impelling her to end her life, features the three-sided gallows of Tyburn and a description of Silvertongue's crime. No doubt the seamy account on the broadside humiliated the countess and was all the more intriguing to the public because it exploited a story of aristocratic vice.

CATALOGUE 2

Maker Unknown
English, 18th century

Last Dying Speech, Birth, Parentage, and Education of That Unfortunate Malefactor, John Clarke...

1750S

Woodcut, 335 x 165 mm
The Houghton Library Collection, Harvard University
*p EB75 A100 7501

This woeful tale details a married gardener's doomed affair with a milkmaid he impregnated and then murdered out of shame. Clarke died on a temporary gallows rather than on the Tyburn triple-tree; the gallows may have been erected near the murder site in order to torment the criminal further and make the crime seem more tangible to the crowd. The very fact that a dying speech was made for Clarke demonstrates that he behaved on the scaffold in the expected dignified manner. If he had acted out violently or protested his innocence to the end, a broadside would not have been printed; insubordination on the scaffold was often interpreted as pure evil.[21]

Isolated signs such as the gallows shape, a distinct and simple form familiar to the citizens of eighteenth-century London, functioned as *memento mori*. Hogarth used the emblematic relation between the image and moralizing text as a symbolic shorthand in his prints. He punctuated his narrative plot lines with potent symbols that evoked clear associations with legal order, punishment, and death. The contemporary importance of the symbols reminded the viewer that Hogarth took on pertinent English themes and events rather than merely replicating scenes from another time and culture.

21. Sharpe 1985, 155.

Laſt Dying SPEECH,

Birth, Parentage, and Education,

Of that unfortunate Malefactor, *John Clarke*, who was executed this Day on a tempory Gallows, erected for that purpoſe, for the Murder of Elizabeth Mann, his Fellow-ſervant, whom he got with Child, and then murdered.

With an affecting Copy of a LETTER written by him to his Wife and three Children the night before his execution.

JOHN Clarke, the unhappy malefactor, was gardner to C. Long, Eſq, where Elizabeth Mann alſo lived as dairy-maid.

He was tried for this murder at Maidſtone, on Wedneſday laſt. It appeared that the unhappy young woman was ſix months gone with child to him.

After a trial, which laſted from ſeven in the morning till twelve, he was found guilty and received ſentence to be executed on Friday, near where he committed the murder. During the whole trial he behaved with the moſt unparelleled firmneſs, to the aſtoniſhment of all preſent.

The firmneſs that he diſplayed on the trial he continued to the laſt. Friday morning he was conducted in a cart from the Jail at Maidſtone to the fatal ſcaffold, where he was in a few moments to terminate his earthly career.

On his way to the fatal tree he behaved with true reſignation to his fate. Though he did not ſeem ſo much effected as men in his ſituation in general are, yet he joined earneſtly in prayer with the Clergymen who attended him.

When the executioner came to faſten the fatal nooſe he begged to be heard a few moments, which being granted, he thus addreſſed the ſurrounding populace:

" *Good Chriſtians, and you young Men in particular,*

" You ſee before you the fatal effects of the indulgence of unlawful paſſions. O young men, take warning by my untimely fate; avoid above every ſin, that of luſt. I have found it, when given way to, one of the moſt deſtructive paſſions. It imperceptibly hurried me on to commit the worſt of crimes, that of murder; had I been contented and happy in the chaſte embraces of a faithful wife I never ſhould have come to this untimely end. I truſt my example will reclaim many.

I heartily forgive my proſecutors and die in peace with all the world. I earneſtly requeſt your prayers for my poor ſinful departing ſoul, Lord have mercy on me and receive my ſoul. *Amen*."

After he had thus ſpoke, he bowed, the execution performed his office; and, on a ſignal being given, he was launched into eternity, amidſt the tears of many.

He was a handſome man, born in the North of Scotland, in the 35th year of his age, of a blooming countenance and pleaſing addreſs: As he paſſed for a ſingle man, he unfortunately prevailed en the too credulous Elizabeth Mann to commit a ſin which coſt them both their lives. Previous to this ſhe bore an excellent character in the family, in which ſhe had lived near four years.

After hanging the uſual time, his body was cut down.

The night before he ſuffered he wrote the following letter to his wife:

" INJUR'D BETSY,

" HOW ſhall I make atonement to you for my paſt errors; how make reparation for the diſtreſſed ſituation into which my guilt has plunged you and my innocent family. Oh! my Betſey, had my love to you been as chaſte as yours to me, how reverſe would have been my ſituation—inſtead of my ignominious death—I ſhould have been bleſs'd and happy in my family and you. Gracious God forgive me, and be your preſerver and the protector of my family. Bear your ſufferings with reſignation, and carefully watch the youth of my young Edward and his ſiſters. Pray for me; as I have done for you and them, and ſhall continue to the lateſt breath of your dying and penitent huſband,

J. CLARKE."

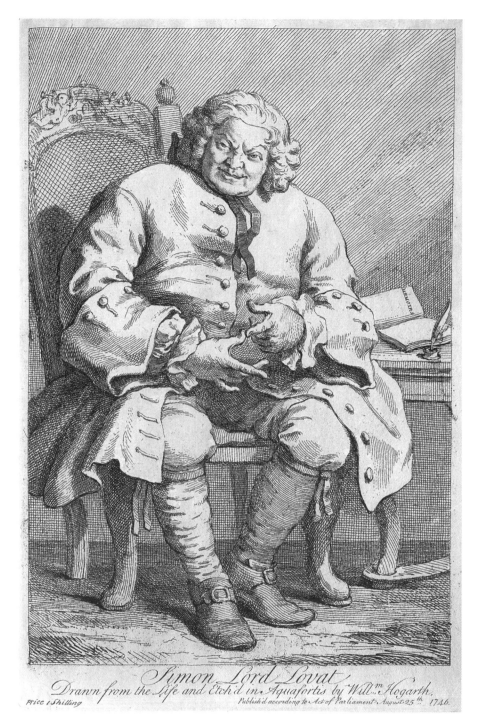

CATALOGUE 3

William Hogarth

Lord Lovat

1746

Etching, 335 x 225 mm
P. 166, BM Sat. 2801 ii/iii
Collection of Suzanne and Gerald Labiner
TL36700.17

Lord Lovat was sentenced to death in 1746 on charges of treason for his role in the failed attempt to restore the exiled Pretender to the English throne. Hogarth visited Lovat to sketch his likeness, and as Hogarth entered the cell, Lovat leapt to embrace the artist as if they were great friends.[22] Hogarth depicts the condemned man seated on a thronelike chair with a royal crown carved into the backrest, an ironic reference to Lovat's sentence of beheading for treason. Death by the sword, the official punishment for traitors, evoked ancient associations with honor and masculinity, and had been a privilege reserved for men of the aristocracy. Fear of humiliation and awareness of the need to fulfill a role, even at his own execution, inspired Lovat to acquire a cushion in his cell to rehearse kneeling and "to try how he should act his part at the fatal block."[23] Lovat was executed in the seclusion of the Tower of London, yet masses still gathered in the streets to be present at the event. The function of the print is complex; it is at once a serious portrait of a historical figure, a satiric exaggeration of the old rebel's bloated features, and a sensational criminal broadside for which Hogarth was rightly certain there would exist a great demand.

22. Paulson 1992, 276.
23. Caulfield 1819–20, 36.

CATALOGUE 4

Thomas Worlidge
English, 1700–1766

Hamet, Companion to Mahomet, Taken Prisoner and Escaped with Him

1760s

Drypoint, 187 x 133 mm
And. 10
Fogg Art Museum, Gift of Belinda L. Randall
from the Collection of John Witt Randall
R14117

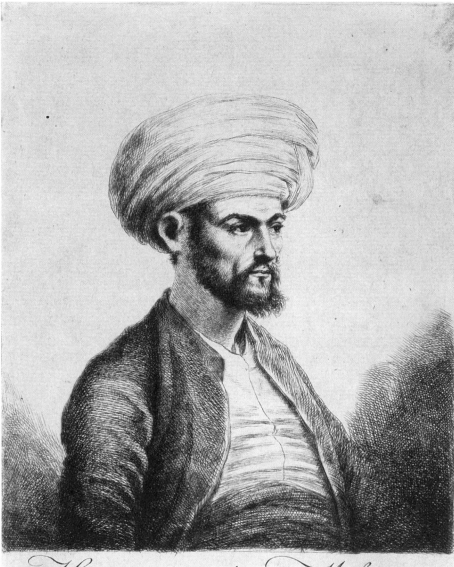

Thomas Worlidge, known in his time as "the English Rembrandt" for his skillful emulation of the old master's style, rendered this portrait of a criminal known to operate in London.[24] Like other artists, Worlidge sought to capitalize on the profitable sale of criminal likenesses. In *Hamet* he stresses the psychological depth of portraiture, a very different approach from Hogarth's conveyance of a larger narrative about the sitter through accessories and details. Unlike the direct and engaging gaze of Hogarth's Lord Lovat (cat. 3), Hamet is presented in near-profile, with emphasis on the curves of his bulbous turban and his simple non-Western clothes. Increased trade traffic at English ports resulted in an influx of foreigners and the development of new types of crime. These factors contributed to a growing interest on the part of lawmen and the general public in the identification of criminals as social and physical "types" and the differentiation of racial characteristics. Intended as a collectible genre piece, this print captured the likeness of an actual criminal and recorded the features of an Eastern man. The portrait was published out of Covent Garden, the location of John Boydell's prolific print shop and the studio of Sir James Thornhill. The credit line indicates that like Hogarth, Worlidge painted a portrait of the criminal and then etched a print from that image.

24. Clayton 1997, 127.

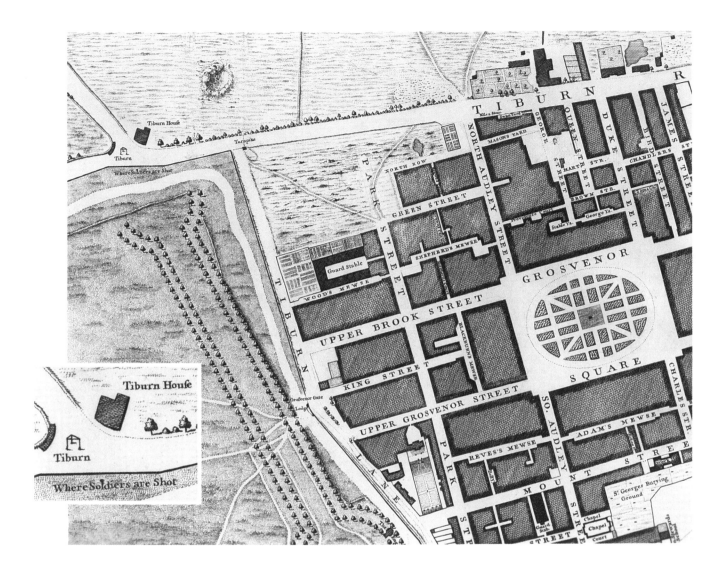

CATALOGUE 5

John Pine
English, 1690–1756

Plate II from *Plan of London*

1746

Engraving, 664 x 498 mm
Harvard Map Collection, Harvard University
MA 200.746 vol. 1 pf

In 1739 John Rocque began preliminary survey work for an engraved map of sprawling urban London and its suburbs titled the "Map of Cities of London and Westminster and Borough of Southwark." Rocque and his partners overcame the tremendous obstacle of demarcating the major neighborhoods, roads, institutions, and parks in a town rapidly metamorphosing into an industrial metropolis. The final product of Rocque's endeavor is a set of twenty-four sheets engraved by John Pine and John Tinney that depict ten thousand acres on the scale of two hundred feet to one inch.[25] Rocque included the distinctive three-sided gallows frame that stood nearly twelve feet high and was positioned between Tyburn House on one side and a high barrier on the other, as seen in Hogarth's print *The Idle 'Prentice Executed at Tyburn* (cat. 7).

The area around Tyburn gallows developed into a prosperous suburb, and as early as the 1750s residents and merchants began to advocate removal of the gallows because of the menacing crowd it attracted.[26] People traveling Tyburn Lane to the Marylebone Gardens for evening festivities forced the Marylebone manager to implement stronger security measures. Darkness and seclusion enabled robbers to pick off carriages full of moneyed, periwigged, and bejeweled folk. Two men swung at Tyburn for an attack on Marylebone employees in 1773.[27]

25. Rocque 1981, vii. 26. Gatrell 1996, 602. 27. Sands 1987, 105.

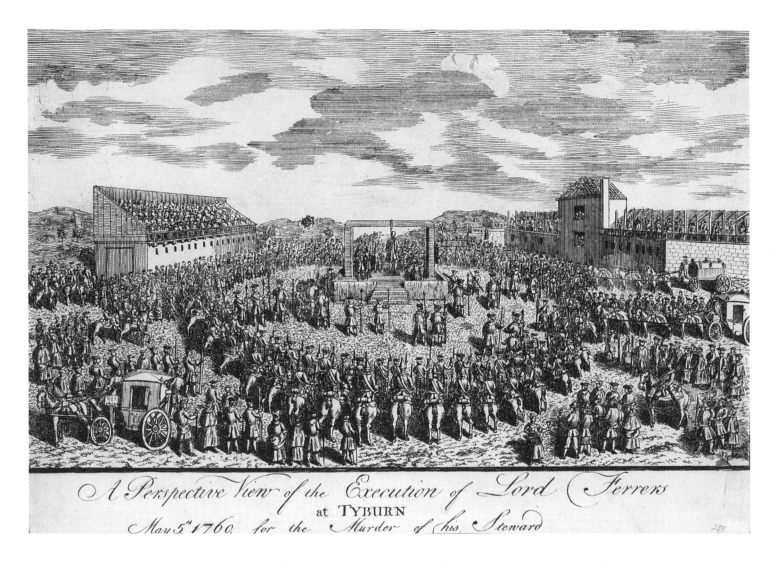

A Perspective View of the Execution of Lord Ferrers at TYBURN May 5th 1760, for the Murder of his Steward

CATALOGUE 6

Maker Unknown
English, 18th century

A Perspective View of the Execution of Earl Ferrers at Tyburn May 5th, 1760, for the Murder of His Steward

1760

Engraving, 225 x 330 mm
Harvard University Law Library, Rare Book
Collection
TL36702.1

This print depicts the execution of Lord Ferrers, a notoriously violent madman who was put to death on 5 May 1760 for slaying his steward. The severity of Ferrers's sentence constituted a drastic change from the corrupt but common practice of allotting lesser punishment to aristocrats, and it accounts for the enormous crowd that attended his hanging.[28] The spatial organization and the central placement of the scaffold reinforce the similarities between the theater and execution spectacles. The artist idealistically represented the attendants as solemn witnesses to the moral lesson. The composition emphasizes the greater visibility provided by the new portable gallows that replaced the Tyburn triple-tree in 1759 on the same site. The technological innovation of the drop door beneath the criminal's feet and the fact that the gallows were only erected on hanging days made it seem a more humane device.[29] The drop was intended to wrench the neck quickly and eliminate the need for family and friends to pull on the condemned person's feet to minimize suffering. The machine, however, operated ineffectively at the execution of Lord Ferrers; he dangled for at least four minutes before being yanked into oblivion.[30]

28. Marks 1909, 250. 29. Ibid., 252. 30. Ibid., 251.

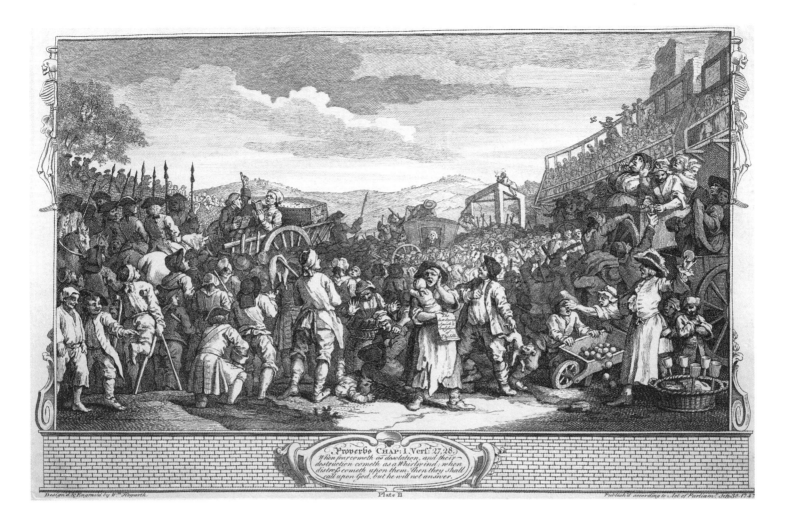

Proverbs CHAP: I. Verſ: 27, 28.
When fear cometh as desolation, and their
destruction cometh as a Whirlwind; when
distreſs cometh upon them, then they shall
call upon God, but he will not answer.

Design'd & Engrav'd by W.m Hogarth. Plate II Publish'd according to Act of Parliam.t Sep.30. 1747.

CATALOGUE 7

William Hogarth

The Idle 'Prentice Executed at Tyburn

1747

Plate XI from *Industry and Idleness*
Etching with engraving, 257 x 400 mm
P. 178, BM Sat. 2989 ii/iii
Collection of Suzanne and Gerald Labiner
TL36700.20

The Idle 'Prentice Executed at Tyburn, which illustrates the arrival of a fictional progression at the gallows, is regarded as an accurate ground-level reproduction of the space around the Tyburn tree; it was published only months after the ultimate version of Rocque's map (cat. 5). The physically withered and terrified protagonist, Thomas Idle, rides with a Methodist minister who preaches frenziedly and ignores Idle. In the foreground a woman selling broadsides hawks Idle's dying speech, which was obviously printed before Idle even stepped on the scaffold and spoke. In the spirit of the event, gawkers purchase fruit and beer before the show, and drunken scrappers roll in the mud. The wild commotion in this picture makes *The Execution of Lord Ferrers* (cat. 6) seem like a still-life study; the contrast attests to Hogarth's remarkable ability to create humorous and complex layers of interaction in a crowd scene. A long progression to Tyburn also rolls across the bridge in the background of Hogarth's 1758 print *The Polling* from the *Four Prints of an Election* series, but at such a distance that the crowd's actions are obscured and the spectacle could be any type of procession. The final plate of the *Industry and Idleness* series, *The Industrious 'Prentice Mayor of London,* depicts a rambunctious crowd following Francis Goodchild, Thomas Idle's diligent doppelganger, in a parade celebrating Goodchild's ascension to the post of mayor of London. The paired prints polarize good and bad behavior and, more subtly, belittle the rowdy crowd that takes equal pleasure in the grim procession and the mayor's parade.

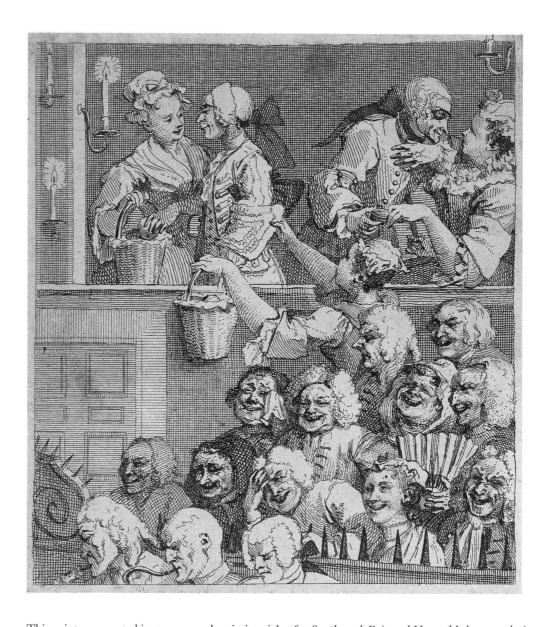

CATALOGUE 8

William Hogarth

The Laughing Audience

1733

Etching, 178 x 158 mm
P. 130, BM Sat. 1949 ii–iii/iv
Collection of Suzanne and Gerald Labiner
TL36700.9

This print was created in 1733 as a subscription ticket for *Southwark Fair* and Hogarth's later work *A Rake's Progress,* published in 1735. The delicately rendered lines and the theme of amorous play reveal the strong influence of the French rococo style on Hogarth's early works. Glances directed toward an unseen stage and between the audience members capture instantaneous and unspoken interactions. Amorousness and commerce blend in the ambiguous activities that transpire on the upper deck. The gentleman at the left, a dandy with a face so exaggerated as to seem sinister, appraises the wares of a young fruit vendor while his cohort aggressively offers snuff to another girl. Hogarth creates a parallel between the audience in the print and the situation of the viewer, who has a privileged look at this flirtation masked by a premise of commerce. Are the fancy men seducing the lower-class women, or are the women competing to charm the fops out of their money for goods or a little more? London's theater districts were known for their wealth of streetwalkers, and the city fostered a notoriously rau-cous nightlife frequented by both rich and poor adventure-seekers. In addition to the risks inherent in prostitution, accused whores could be condemned to execution: their occupation was one of the many activities defined (although erratically enforced) as a capital offense under the Bloody Code.

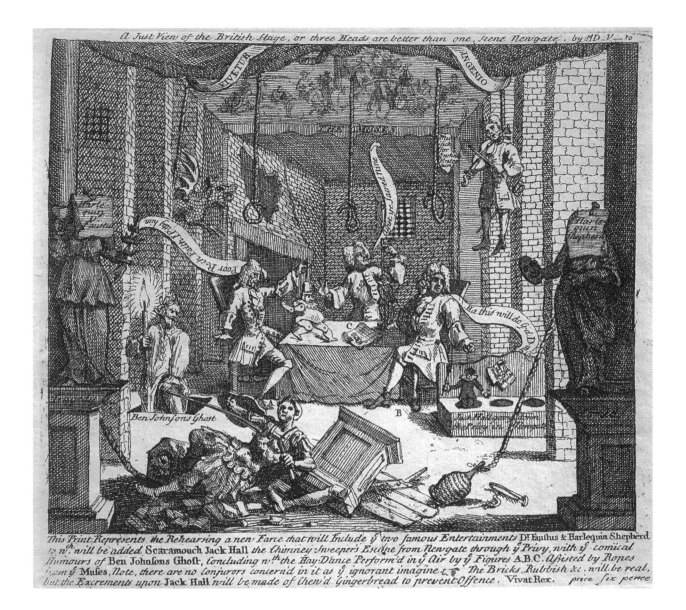

CATALOGUE 9

William Hogarth

A Just View of the British Stage

1724

Etching, 181 x 212 mm
P. 45, BM Sat. 1761 ii/ii
Collection of Suzanne and Gerald Labiner
TL36700.2

In *A Just View of the British Stage,* from 1724, Hogarth merged the theater with the executioner's platform to criticize lowbrow productions run by the directors of the Drury Lane Theater. The scene is set in Newgate Prison on a stage choked with shoddy gag props; in the text is a sincere pledge that "chewed gingerbread" will stand in for "excrement" so as not "to offend." Through the visual device of three nooses dangling over their heads, the print calls for a "just" mock lynching of these pandering arbiters of taste. One recurring theme in Hogarth's work is that English taste in art had been watered down by an interest in the foreign; hence sheets from folios of Shakespeare's plays have been stuffed in the latrine. Reflecting the popular fascination with the figure of the condemned criminal, a sheet with "Harle-quin Shepherd" printed on it, a reference to a popular drama based on the adventures of folk hero and thief Jack Sheppard, is nailed to the head of the statue representing Comedy. The roughness of the lines results from the artist's inexperience at this early stage in his career and emphasizes Hogarth's distaste for the subject.

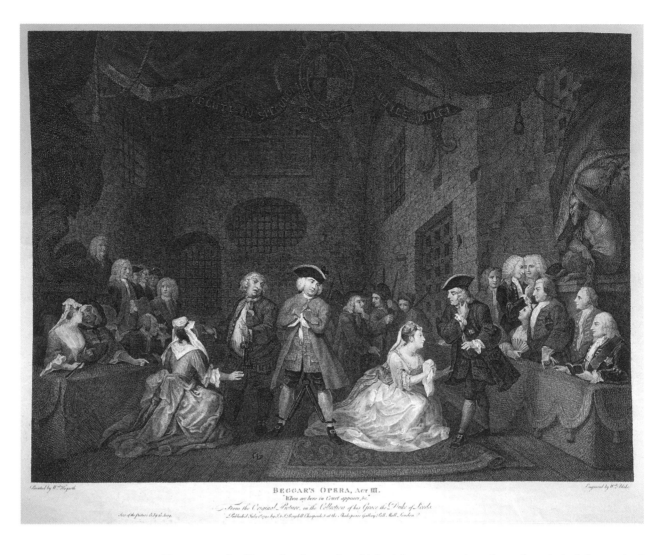

CATALOGUE 10

William Blake
English, 1757–1827

The Beggar's Opera, Act III, after Hogarth

Engraving, 450 x 584 mm
E. 48
Collection of Suzanne and Gerald Labiner
TL36700.29

Four years after Hogarth vehemently criticized the presentation of popular criminal dramas in *A Just View of the British Stage,* he painted five versions of a scene from John Gay's 1728 musical *The Beggar's Opera.* Blake's 1788 print after one of the Hogarth paintings depicts a climactic scene on a stage that represents Newgate Prison. The tawdry heroines Polly Peachum and Lucy Lockit plead with their fathers to help save the life of their lover, the condemned highwayman Captain Macheath. Macheath epitomizes the romantic and rebellious stereotype of the condemned man, strong and charismatic despite being restrained in fetters. One female character in the play fetishizes the neck area of the doomed "Adonis" in song: "Beneath the left ear so fit but a cord/ A rope so charming a zone is!"[31] Hogarth replicated a drama that cast criminals and whores in the format of high opera to reinforce the author's goal of mocking the supposed sanctity of upper-class morality. Gay's most pointed jab was the character Macheath, a satire of Sir Robert Walpole, the man who defined the office of England's prime minister. In 1738 Walpole issued a ban on performances of *Polly,* the sequel to *The Beggar's Opera,* for fear that it would contain even more material parodying his private affairs than its precursor had; bolstered by Walpole's opposition, *Polly* was a great commercial triumph in the end.[32]

31. Gay 1986, 48. 32. Ibid., 1.

EXECUTION PROPER

A S HOGARTH MADE THE TRANSITION FROM CRAFTSMAN TO ARTIST, he established a wickedly spiteful position against stereotypical and obvious authority figures. He embraced the strategy of past literary and graphic parodists who had ridiculed arbiters of artistic, social, and political institutions by direct attack rather than through gentle jocularity.[33] This barbed style suited Hogarth's quick wit and complemented his intention to confront contemporary manners. The oppression of common people by arrogant and rapacious rulers, Hogarth's theme with variations throughout his career, was perhaps forged by personal experience. William tremendously admired his father, Richard, a writer and Latin scholar, and bore his father's failures heavily. Inconsistent patronage from booksellers and the closure of his Latin-language-themed coffeehouse left Richard destitute. The Hogarth family lived for seven of William's childhood years in the debtor's prison on Fleet Street; two of William's brothers died during that confinement, and Richard lived only a few years after the family's release.[34] The brutal specter of prison hardship seems to have haunted the artist's work and influenced his perception of social power structures. Ronald Paulson makes a similar observation when he states that Hogarth's "emphasis throughout his work is on prisons, real and metaphorical."[35]

Many of Hogarth's early prints, those produced between 1720 and 1725, explore and critique one type of "metaphorical prison": public control and the submissive relation of citizen to state.[36] Hogarth emulated the fluid style of French etcher Jacques Callot (1592–1635) as embodied in his print series known as *The Large Miseries of War,* dated to 1633–35 (cat. 11a–b). The size, violent subject matter, and surging lines in the engravings that Hogarth was commissioned to make for John Beaver's 1725 book *The Roman Military Punishments* (cat. 12) show Hogarth's stylistic indebtedness to Callot. Information about Beaver and the history of this book is scarce. However, the subject matter and the timing of the plates' commission seem to indicate an awareness of the parallels between castigation in the Roman Republic and civic regulation in contemporary England that deserves attention. Agonized figures derived in pose and context from Callot's work but swathed in an allegorical atmosphere inspired by French engraver Bernard Picart (1673–1733) also appeared in *An Emblematical Print on the South Sea Scheme* (cat. 13). Hogarth gained great inspiration and instruction from sixteenth- and seventeenth-century foreign art; however, after he came into his own style, he sharply criticized English collectors who revered old master art over that created by their own countrymen.

Later in his career Hogarth demonstrated in prints and writings his concern for public morality and behavior, and he expressed an aspiration to improve it through art. With regard to the 1751 publication of the *Gin Lane* (cat. 35) and *Beer Street* set and *The Four Stages of Cruelty* series, Hogarth stated that the images were "made as obvious as possible, in the hope that their tendency might be seen by men of the lowest rank."[37] He claimed to sacrifice "fine engraving" in order to make the prints affordable and digestible to the poor and uneducated.[38] In the 1758 etched and engraved print *The Bench* (cat. 14), he directed sharp criticism toward legal officers charged with the protection of the lower classes whom he had attempted to edify in the prints of 1751. Numerous posts in law enforcement and in the management of Newgate Prison were purchased as contracts known for providing dependable income during lean times, but were notoriously susceptible to corruption. Although Hogarth exposed vice, hypocrisy, and human weakness in his images of important men, he knew many of those whom he satirized. He was a brilliant opportunist whose desire for success led him to cultivate beneficial acquaintanceships.[39]

Hogarth's prints depict and satirize masculine nefarious experience, and could be subtitled "The Hanoverian Norms of Deviance."[40] His poor scoundrels and his aristocrats alike harbored weaknesses for drink, easy sex, and appropriation of other men's property, but the aristocracy had an extra layer of temptation. Consumption of luxury goods such as gold and silver work (cat. 15a–c), the class of object Hogarth experienced firsthand as a goldsmith's apprentice, was a charged topic in the press, literature, and political oration. In a contemporary drawing made after Hogarth's print *Some Principal Inhabitants of Ye Moon: Royalty, Episcopacy, and Law* (cat. 16), luxury goods are animated in a manner that mocks the three representatives of powerful institutions for being greedy, hollow assemblages of covetous objects.

A 1720 pamphlet written by Richard Mead blamed imported fabrics, furs, and feathers—dry goods for rich women and fops—for conveying disease, instead of blaming the vermin that infested the trade ships.[41] Hogarth parodied fashion and effeminately styled men's garments as a French aberration in his portrayal of the fancy musicians shown in the second plate of *A Rake's Progress* (cat. 17). Men were predisposed toward crime through participation in nighttime carousing and through the carrying of weapons. In the same print, the main character, Thomas Rakewell, hires a body-double to protect himself from the faddish (although illegal) behavior of dueling for defense of reputation and property.

Hogarth was very aware of the status of the whore, another hired body, as "a human being and at the same time a commodity."[42] The third plates of *A Rake's Progress* (cat. 18) and *Marriage à la Mode* (cat. 19) could be read as a continuous story about the consequences of young English noblemen trysting with whores and then becoming afflicted with their diseases. The two plates parallel the thought Mandeville put forth in 1714 in *The Fable of the Bees,* namely that commerce in luxury goods was a seductive but infectious pursuit that would eventually pollute the nation.

Sexually contracted diseases were a less discriminating punisher than was another corrupt Hanoverian agent, the court-of-law system commonly called the Black (or Bloody) Assizes. Wealth and social stature determined a person's standing before the law, and aristocrats were granted lenient penalties, if any at all were issued. In 1706, the benefit of clergy, a provision that had allowed accused felons to be excused if they

could prove literacy by reading from a Bible, was thrown out, but rich and influential malefactors could still bribe their way out of a conviction.

Prison detainment did not constitute castigation as it does today; it more often functioned to hold people waiting for trial.[43] Constrained debtors, as Rakewell becomes in the fourth plate of *A Rake's Progress* (cat. 20), resided in a separate wing from accused felons, the class of criminal the lawyer Silvertongue attempts to avoid joining in the fifth plate of *Marriage à la Mode* (cat. 21). A stay in prison cost money in rent and bribes, called garnish money. For a price, alcohol and female companionship could be imported. The seventh plate of *A Rake's Progress* shows Rakewell sinking ever more deeply into debt; a keeper at Fleet Street points at a page from the ledger and demands that Rakewell pay his garnish money.

In the Hanoverian period, the ideology of liberty collided with a need to curb crime in the wake of London's expansive urban development. A solution was sought in the adoption of stronger laws rather than in the creation of a police force.[44] Citizens, beadles, constables, and soldiers largely carried out the system of civic patrol and order. In another connection between printed material and criminal culture, a successful arrest that would probably lead to an execution merited an actual engraved certificate called a "Tyburn ticket" for the arresting individual; such a ticket excused the bearer from further obligatory law-enforcement duties.[45]

Toward the end of the eighteenth century, the number of penalties listed under the Bloody Code increased, and the punishments grew more severe. Despite an increase in the number of crimes designated as capital offenses, juries more frequently hesitated to send people to certain death; as a result, the hanging rate remained stable.[46] Transportation to a criminal colony and branding of the hand were two of the few options between a pardon and an execution that existed on the books (although transportees were under pain of death if they returned). Once condemned, criminals of the lower classes rarely received a last-minute pardon despite the often riotous protestations voiced by the crowd.

Hanging was not the only misfortune met by Hogarth's characters, but allusions to it inform representations of alternative punishment. In a reference to one such punishment, criminal transportation, the fifth plate of *Industry and Idleness* (cat. 22) shows Thomas Idle as an indentured sailor, a notoriously meager and brutal existence. Idle's boat runs parallel to a jutting finger of land on which an exposed corpse dangles from a gibbet, reinforcing the seriousness of transportation as a punishment. England perpetuated the old European practice of maintaining a dock gallows as a warning of justice to arriving ships; Netherlandish artist Pieter Bast (d. 1605) also recorded this custom in the sixteenth century (cat. 23).

The bodies of the poor, who were more likely to be accused of crimes and put to death than any other demographic group,[47] served as raw material for anatomical studies. On occasion a flayed corpse was procured in place of a cast for anatomical drawing sessions at the Royal Academy, but corpses for study were most eagerly sought by surgeons. Physical fights for possession of the body often erupted between surgeons and the executed criminal's family. Mandeville thought it folly for families to "venture to have their Bones broke, for endeavoring to deprive Surgeons of the Means to understand the Structure of them."[48] The 1752 Murder Act added to execution a post-mortem dimension of terror, shameful punishment, and deterrence for spectators by ordering the release of hanged criminals to surgeons for dissection. Before the Act's passage, some convicts

had sold their bodies to surgeons in advance to earn money for their families or to afford a nice suit of clothes in which to hang. Clothing worn by the condemned was stripped from the corpse and given to the hangman as part of his fee.[49]

Adding to the condemned's reluctance to contribute to scientific knowledge was the valid possibility of revival upon the surgeon's slab. Insufficient methods for verifying death led to accidents that evolved into legendary accounts, such as the story of one hanged convict who "returned to life" after being prepared for dissection. Another hanged "corpse" was declared dead and awoke in her coffin. She upset the lid by sitting upright, terrifying the cart driver conveying her body back to London.[50] The 1752 Murder Act was also meant to circumvent the practice of grave robbing and the grisly fights between the dead criminal's family and surgeons over the body. Hogarth's engraving *The Reward of Cruelty* (cat. 24) anticipates passage of the Murder Act of 1752 by one year. He intended for the image to be didactic but its message is ambiguous: does the viewer sympathize with Thomas Nero for his suffering or laugh at the humiliation and pain he earned?

In the lower left corner of each plate of the engraved *Four Stages of Cruelty* prints (cats. 24 and 38) is the price of one shilling. Hogarth oversaw John Bell's (fl. 1750s) translation of the drawing for *The Reward of Cruelty* into a woodcut (cat. 25), which yielded an ominous and fittingly brutal effect. Bell's woodcuts were sold for less than the engraved prints of the series, supposedly to reach consumers of the laboring classes "to whom they were intended to be useful."[51] The sum Hogarth charged for his own prints varied with their production costs, the ornateness of design, and the class of the target audience. He charged one shilling for his *Lord Lovat* (cat. 3), a topical criminal portrait, and two guineas each for the eight plates in the series *A Rake's Progress*.[52] However, as Paulson has pointed out, a journeyman earned under two shillings for a day's labor and even a one-shilling print was a significant purchase for the social stratum Hogarth aspired to edify with *The Four Stages of Cruelty* series.[53] Hacks made cheap woodcuts that objectified the swinging corpse, without the visual context or narrative content that Hogarth provided. Through the lens of satire, Hogarth's larger view drew attention to the natural but grim impulse that motivated attendance at executions or tours of Bedlam (cat. 26) as curious amusement.

Still another meaning of *execution* was the seizure of property after a legally mediated conflict, as illustrated in *The Body of a Murderer Exposed in the Theatre of the Surgeons Hall, Old Bailey* (cat. 27) engraved for *The Malefactor's Register: or, the Newgate and Tyburn Calendar* by an artist identified as White.[54] In this image the criminal's body has been doubly executed; the state terminated his life and then confiscated the body for anatomization by the surgeons. Both *The Reward of Cruelty* (cat. 24) and this image harshly confront the actual dissected body and convey some of the physical realities of the act of hanging that have frequently been "sanitized" in modern scholarship.[55] Dying speeches recounted orderly executions, but many criminals were dragged to the scaffold kicking and wailing in terror. The normal physiological reactions to this kind of death included bodily twitching, a blackened face, the loss of control of bladder and bowels, or a post-mortem erection. The mind and body of the condemned were thoroughly punished (as, to

some degree, were those of the observer), and advocates of dissection thought castigation should continue after death, a fact apparent in these two images.

In *The Company of Undertakers* (cat. 28), Hogarth ridiculed the dubious diagnostic methods and incompetence of doctors by characterizing them as bringers of death rather than relief. Antagonism toward surgeons who obtained corpses from the gallows had apparently peaked in 1678 when the Tyburn triple-tree was razed overnight, "as if the gallows it self had been Hang'd, drawn, and quarter'd."[56] An anonymously penned pamphlet from the collection at the Houghton Library describes the event in a mock-heroic tone and likens the fragmented lumber of the gallows to the broken body of an executed felon. "What a wicked Age do we live in," the author mischievously bemoans, "when even the Gallows is not safe from being Robb'd," and suggests that the splinters could be gathered as ingredients for doctors' sham medical potions.[57]

33. In this he owed a great debt to both English and foreign satirists of the seventeenth century. Godfrey 1984, 26.

34. In mentioning Hogarth's childhood I do not wish to sentimentalize him, but rather to acknowledge pertinent information that undoubtedly influenced his character. A fuller account of this period in Hogarth's life can be found in Paulson 1992 (vol. 2), 33–64. An excellent argument against a simplistic reading of Hogarth as a champion of the underdog can be found in Bindman 1992, 45–58.

35. Paulson 1991, 33.

36. Again, Paulson has made a point similar to the one I wish to make about the influence of the prison experience on the manner in which Hogarth expressed in prints his perception of civic power structures. Paulson says: "[Hogarth's] basic assumption seems to have been that society should be seen from the point of view of the prisoners rather than their judges and warders: ultimately from the marginal point of view of the child, or of the child locked up in prison with his parents." This quote and my re-application of the prison idea are from ibid., 33.

37. Hogarth 1833, 64.

38. Ibid., 64–65.

39. One interesting example is the occasion on which Hogarth painted members of the House of Commons Committee on Prisons. See Bindman 1992, 49–51.

40. I use "Hanoverian" in the general sense, referring to the eighteenth century. I am working with ideology of gender difference that numerous scholars of eighteenth-century studies have mapped out: women were regarded as lesser emotional, physical, and intellectual beings in comparison to men, the norm for measure. As will be discussed in the third section of this catalogue, the parameters of female deviance were defined very differently. The topic of male sexual "deviance" and the criminalization of homosexuality is too broad a topic to be included here. Jill Campbell, for one, has written well on eighteenth-century perceptions of gender and male sexuality.

41. Mead 1720, 17.

42. Paulson 1995, 383.

43. Spierenburg 1995, 65–66.

44. Swanson 1990, 46.

45. McLynn 1989, 19.

46. Ibid., xv.

47. This is the thrust of the fascinating essay "Tyburnology: Sociology of the Condemned" from Linebaugh 1991, 73–111.

48. Mandeville 1725, 28.

49. Linebaugh 1975, 71.

50. This and other fantastic tales of post-execution revival are in Marks 1909, 223–26.

51. The intaglio version of this image was made in two editions, one of a higher quality. In speaking of these prints Hogarth wrote that "[n]either minute accuracy of design, nor fine engraving were deemed necessary. ... passions may be more forcibly expressed by a bold stroke, than by the most delicate engraving." Hogarth 1833, 64–65.

52. Print cost from Paulson 1992 (vol. 2), 43.

53. Information on wages from Paulson 1992 (vol. 3), 25.

54. Johnson 1755, 8 M2r.

55. I agree with V. A. C. Gatrell's assertion that acknowledging the punishment on a physical level is a significant part of understanding public curiosity about it and why it continued to be used as a deterrent to crime. Gatrell 1996, 29.

56. *The Tyburn-Ghost* 1678, 7.

57. Ibid., 5.

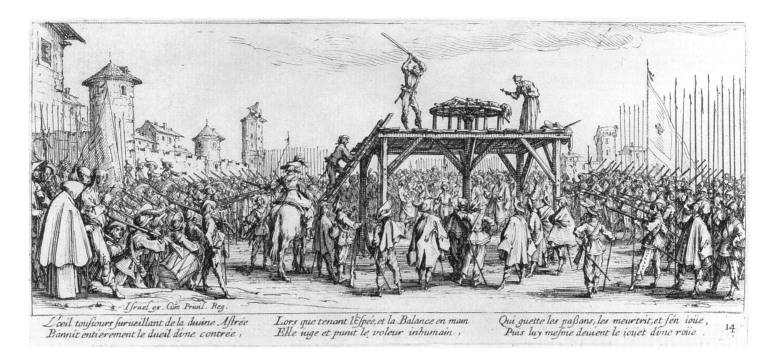

L'œil tousiours suru̇eillant de la diu̇ne Astreé
Bannit entièrement le dueil d'u̇ne contreé ,

Lors que tenant l'Espeé,et la Balance en main
Elle iu̇ge et punit le voleur inhumain ,

Qui guette les paßans, les meurtrit,et s'en ioüe,
Puis luy mesme deu̇ient le ioüet d'u̇ne roüe.

s. Israel ex. Gim Priu̇l. Reg.

14

CATALOGUE 11a

Jacques Callot
French, 1592–1635

Hanging Renegades

Plate XI from *The Large Miseries of War*

1633–35

Etching, 85 x 189 mm
L. 1349, M. 574 ii/iii
Fogg Art Museum, Gray Collection of Engravings, by Exchange
S4.15.3
(Not illustrated)

CATALOGUE 11b

Breaking Renegades on the Wheel

Plate XIV from *The Large Miseries of War*

1633–35

Etching, 89 x 191 mm
L. 1352, M. 577 ii/iii
Fogg Art Museum, Gray Collection of Engravings, by Exchange
S4.16.2

In the 1720s an English school of engraving as graphic art, as opposed to the applied craft tradition, was practically nonexistent. This led Hogarth to study prints by French and Dutch intaglio artists, particularly those who made original prints, and English translations of manuals on the etching technique. The diminutive scale of Callot's prints was congenial to Hogarth, who had engraved small metal objects as an apprentice. From French artists Hogarth absorbed a sense of space inspired by the theater, the use of allegorical figures, and a painterly rendering of modulated lines. In these two works from Callot's *The Large Miseries of War,* the physical realm of the spectator is separated from but integral to the cruel action, much like a theatrical setting. Hogarth would replicate Callot's dramatically posed figures from different angles and relocate them within a slightly different context. Callot formatted both of these images to contain couplets of verse with a moral message that offsets some of the ghastly graphic content, a technique also imitated by Hogarth.

CATALOGUE 12

William Hogarth

The Roman Military Punishments

"Beheading," p. 1

London, 1725

Etching, 43 x 79 mm
P. 60
The Houghton Library, Harvard
University, C. E. Norton Fund, 1956
Houghton Accessions *56–198

Hogarth etched fourteen chapter-head illustrations for John Beaver's now rare book *The Roman Military Punishments,* published in 1725. The plates were a commission, as Hogarth did not participate in the writing of the text; I shall suggest here possible ways of reading a broader context for these fascinating images.[58] The most obvious would be that the young artist accepted the commission because he could easily copy Callot's model (cat. 11a–b) and he needed the cash. The gruesome depiction of soldiers consumed in disciplining their own kind gave Hogarth occasion to merge complex figural interests with a rolling, pastoral landscape. He conveyed powerful action through slight modulations in vigorous lines, as seen, for example, in the portrayal of a soldier who brandishes a weapon above his head.

That soldiers were the subject matter is compelling, given Hogarth's times. Britain venerated its sailors for defending national interests on the high seas, but land-bound soldiers were less popular because, prior to the establishment of a police force, they were summoned to suppress their fellow countrymen in instances of civic unrest. Hogarth etched the plates for *The Roman Military Punishments* during the tenure of the 1715 Riot Act, which allowed crowds of a dozen or more people just fifty-nine minutes to assemble in protest; beyond that, the military could be called in to end a meeting forcibly.[59]

Considering Hogarth's loathing for aristocrats who revered classical art over that produced by living artists, it is perhaps not surprising that he took on work that illustrates republican Roman history at its most brutal. However, there is reason to believe that the project was not conceived entirely as denigration. David Bindman has explained that, shortly after publication of the *Roman Military Punishments,* the anti-Walpole movement, or Opposition, began to reject the ideals of "Roman republican virtue" as an ideological weapon in a war to represent true nationalism.[60] In the "late 1730s and 40s" the Opposition began to portray itself as keeping alive the values of the Elizabethan Age, which it saw as a pinnacle of arts and freedom in England.[61] Perhaps, then, the images in Beaver's 1725 book depicting a show of force that set standards of social control was an acknowledgment of how England had learned from and improved on the institutions of its cultural forebears.[62]

58. At some point the plates were printed independently, most likely between 1725 and 1779; Suzanne and Gerald Labiner own a set. Paulson 1970, 113. Because they were made for a specific text and are bound to this context, I have taken into consideration that the images cannot be treated loosely or as autonomous works.

59. McLynn 1989, 219.

60. Bindman 1992, 54–56.

61. Ibid., 54.

62. Bindman places Hogarth on the side of the Opposition at this time.

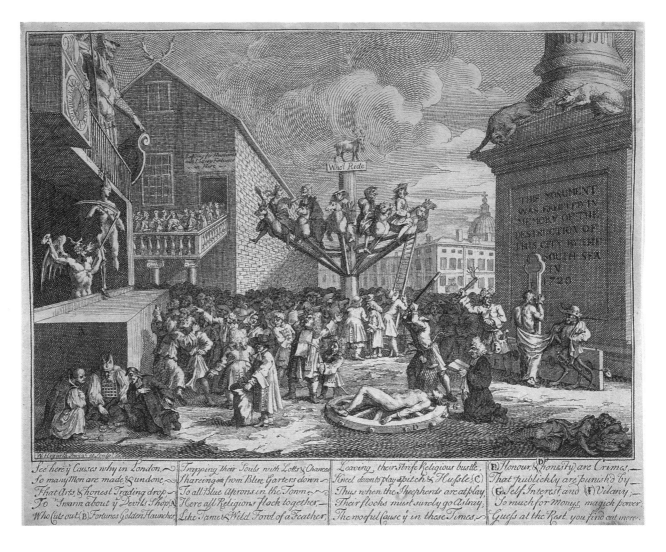

CATALOGUE 13

William Hogarth

An Emblematical Print on the South Sea Scheme

1721

Etching and engraving, 222 x 317 mm
P. 10, BM Sat. 1722 ii/vii
Collection of Suzanne and Gerald Labiner
TL36700.1

Although not published until 1724, this 1721 plate was Hogarth's first full print. The elaborate and allegorical iconography burlesqued the greed of the English government, which led to its liability for the collapse of the South Sea Company, a precarious commercial network of trade, credit, and investment. The monarchy and government had gambled with the national economy by allotting a monopoly on trade to John Law; the consequences of that decision imploded in 1720. Family fortunes evaporated overnight and financial desperation caused an increase in criminal activity. Of particular interest here is the allegorical and urban genre scene in the foreground. The Devil hacks at the carcass of Fortune, while Vilany [*sic*] flagellates Honor at the foot of the London Monument to the fire of 1666. The expired figure of Honest Trade languishes on the shadowy ground in allusion to ambivalent attitudes toward imported luxury goods as objects with the power to debauch. In another overlap between entertainment and law, a squat child-pickpocket, so common at hangings that such children were dubbed "Tyburn blossoms," slips a hand into the jacket of Hogarth's friend, the playwright John Gay, who was bankrupted by the South Sea Company disaster.[63]

63. Paulson 1970, 95.

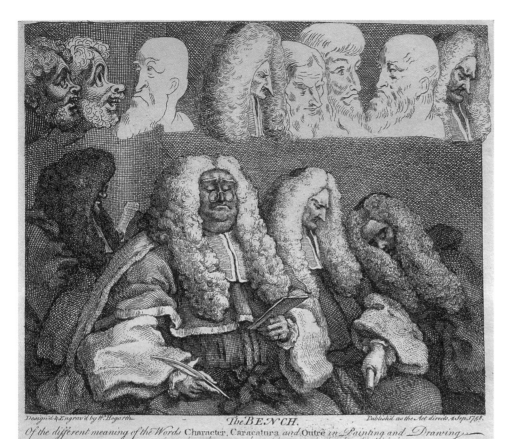

The BENCH.

Of the different meaning of the Words Character, Caracatura and Outrè in Painting and Drawing.

Design'd & Engrav'd by W. Hogarth. Publish'd as the Act directs, 4 Sep. 1758.

There are hardly any two things more essentially different than Character and Caracatura nevertheless they are usually confounded and mistaken for each other: on which account this Explanation is attempted It has ever been allow'd that, when a Character is strongly mark'd in the living Face, it may be considered as an Index of the mind, to express which with any degree of justness in Painting, requires the utmost Efforts of a great Master. Now that which has, of late Years, got the name of Caracatura, is, or ought to be totally divested of every Stroke that hath a tendency to good Drawing: it may be said to be a Species of Lines that are produced rather by the hand of chance than of Skill; for the early Scrawlings of a Child which do but barely hint an Idea of an Human Face, will always be found to be like some Person or other, and will often form such a Comical Resemblance as in all probability the most eminent Caracaturers of these times will not be able to equal with Design, be cause their Ideas of Objects are so much more perfect than Childrens, that they will unavoidably introduce some kind of Drawing; for all the humourous Effects of the fashionable manner of Caracaturing chiefly depend on the surprize we are under at finding our selves caught with any sort of Similitude in objects absolutely re-mote in their kind. Let it be observ'd the more remote in their Nature the greater is the Excellence of these Pieces; as a proof of this, I remember a famous Caracatura of a certain Italian Singer, that Struck at first sight, which consisted only of a Streight perpendicular Stroke with a Dot over it. As to the French word Outrè it is different from the foregoing, and signifies nothing more than the exagerated outlines of a Figure, all the parts of which may be in other respects, a perfect and true Picture of Nature. A Giant may be call'd a common Man Outrè. So any part as a Nose, or a Leg, made bigger or less than it ought to be, is that part Outrè, † which is all that is to be understood by this word, so injudiciously us'd to the prejudice of Character. —— See Excess Analysis of Beauty. Chap. 6.

** The unfinish'd Groupe of Heads in the upper part of this Print was added by the Author in Oct. 1764: It was intended as a further Illustration of what is here said concerning Character Caracatura & Outrè. He worked upon it the Day before his Death which happened the 26th of that Month.

CATALOGUE 14

William Hogarth

The Bench

1758

Etching and engraving, 197 x 209 mm
P. 205, BM Sat. 3662 v/vi
Collection of Suzanne and Gerald Labiner
TL36700.22

In this print, Hogarth satirized the archetypal figure of the flagrantly bribable judge while nonetheless recognizing the intimidating presence that this post had in people's minds. Courtroom judges wielded power over life and death; by 1815 approximately 225 capital crimes ranging from murder to \the pickpocketing of two shillings had accu-mulated in the books.[64] Chief Justice John Wiles, rendered here second from the left, did not hesitate to excoriate the prisoners whom he condemned; in doing so he exer-cised the meaning of the verb "to *Gallow*," which Johnson designated as "to terrify."[65] In this 1758 image Hogarth presents the judges from the Court of Common Pleas in formal, voluminous wigs and billowing robes: they are icons of the disreputable legal system. The print exhibits Hogarth's technical aptitude, and demonstrates his the-ory on the role of line in "Character" versus "Caricatura," as explained in the lower regis-ter of the print. He put theory into practice by adding to the plate shortly before he died the grotesque and incomplete faces strung along the upper edge, some derived from paintings by Leonardo and Raphael.[66] The distorted whole judges are not devoid of a certain gentleness in their facial details; this sensitivity distinguishes them from the parade of malformed heads above.

64. McLynn 1989, xi.

65. Information on Wiles is in the caption under the first plate in Hay et al. 1975. Definition of "to *Gallow*" is from Johnson 1755, 10B2v.

66. Sources for the grotesque heads are named in Paulson 1970, 239. Plate reworking is noted in Uglow 1997, 696–97.

CATALOGUE 15a

John Lampfert

English, 18th century

Tankard

London, 1778–79

Silver, h. 21.2 cm
Fogg Art Museum, Bequest of Edwin H. Abbot
1966.51.67

CATALOGUE 15b

Maker Unknown

English, 18th century

Georgian Plain Pistol-Handled Table Knife with Straps to the Handle

Engraved silver, l. 24.1 cm
Fogg Art Museum, Gift of Mary Henle
1989.47.01
(Not illustrated)

CATALOGUE 15c

Maker Unknown

English, 18th century

Georgian Cheese Knife

Engraved silver, l. 19.7 cm
Fogg Art Museum, Gift of Mary Henle
1989.48.01
(Not illustrated)

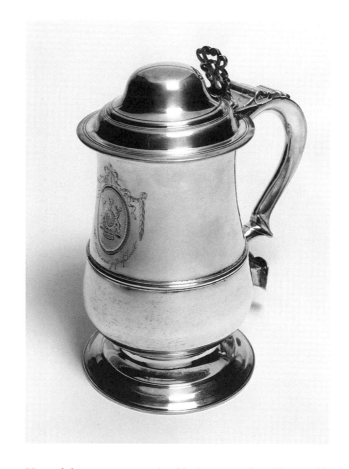

Hogarth began an apprenticeship in 1714 under Ellis Gamble, a goldsmith's engraver, immediately after his family was released from the Fleet Street debtors' prison. As the guild rules dictated, young Hogarth lived with Gamble and learned the repetitious practice of engraving emblems on metalwork. The collection of luxury goods by middle-class and aristocratic consumers fostered a two-sided industry of production and theft. Silverware, tankards, and tea services—the mundane objects that figured so prominently in Hogarth's apprenticeship—were the exact objects people stole and for whose theft they later swung by their necks at Tyburn gallows. Under the statutes of the Bloody Code the successful theft of silverware or tankards from a home even without a witness constituted capital crime.[67] Silver objects would later adorn Hogarth's prints as signs of excess: some examples are the elegant silver stolen by Ann Gill in *Cruelty in Perfection* (cat. 38), the platter prepared for the lewd dance in the tavern scene from *A Rake's Progress* (cat. 18), and the empty teapot-heads of the adoring courtiers in *Some of the Principal Inhabitants of Ye Moon: Royalty, Episcopacy and Law* (cat. 16).

67. McLynn 1989, xii.

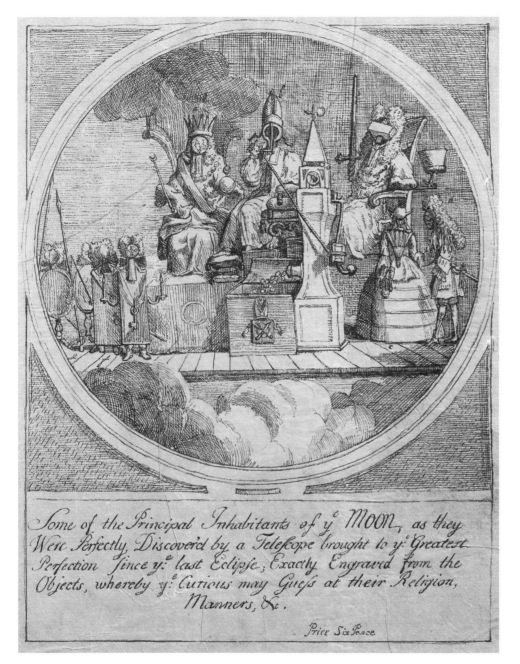

Maker Unknown

English, 18th century

Some of the Principal Inhabitants of Ye Moon: Royalty, Episcopacy and Law

after Hogarth, early 18th century

Ink drawing on laid paper, 262 x 206 mm
Collection of Suzanne and Gerald Labiner
TL36700.31

This drawing was copied after a 1724 print by Hogarth that attacked a trinity of indifferent arbiter types, their figures composed from luxury goods and absurd symbols to show their abuse of power. The greedy king's face is a coin, the bishop's head is a Jew's harp plucked to lull the masses with its coarse twang, and a blunt-ended mallet stands in for the skull of the punishing magistrate. Placement of the rulers on the moon mocks a continental-style ceiling painting commission that Sir James Thornhill had been working on (at the time he was Hogarth's drawing teacher), as well as contemporary hysteria over an impending eclipse.[68] With this reference to the heavens, Hogarth also unfavorably compares the excessive lifestyles of the Whig supporters of King George II to the court of King James II, whom the Whigs overthrew in the Glorious Revolution of 1688. This timely representation of power and greed indicates Hogarth's belief that despite political upheaval, the divine right of kings and the privilege of wealth had not been reformed entirely.

68. Paulson 1971, 127.

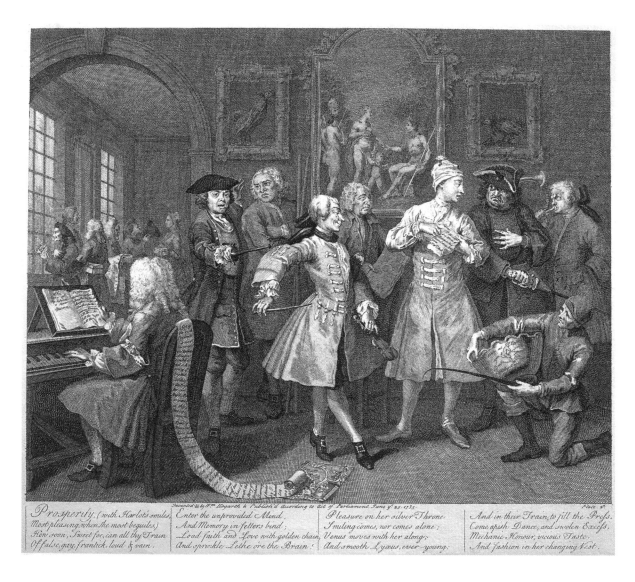

Prosperity, (with Harlots smiles)
Most pleasing, when she most beguiles,)
How soon, Sweet foe, can all thy Train
Of false, gay, frantick, loud & vain.

Enter the unprovided Mind,
And Memory in fetters bind;
Load faith and Love with golden chain,
And sprinkle Lethe ore the Brain;

Pleasure on her silver Throne
Smiling comes, nor comes alone;
Venus moves with her along;
And smooth Lyæus, ever-young;

And in their Train, to fill the Prefs,
Come apish Dance, and swolen Excefs,
Mechanic Honour, vicious Taste,
And fashion in her changing Vest.

CATALOGUE 17

William Hogarth

A Rake's Progress

PLATE II, 1735

Etching and engraving, 314 x 387 mm
P. 133, BM Sat. 2173 iv/v
Collection of Suzanne and Gerald Labiner
TL36700.10

A Rake's Progress documents the misadventures and immoderate behavior of Tom Rakewell, a young man plunged into inherited wealth. This second plate of the 1735 series exposes the superficial veneer of respectability that Rakewell has acquired through purchase. The rake dabbles in the fashionable interests of a leisured gentleman, as personified in the men swarming around him: fancy clothes, race-horses, and fencing lessons. These pastimes prepare the hedonistic youth for an untethered existence of whoring, dueling, gambling, and drinking. Two exasperated Englishmen, one holding a plan for an estate garden, have been pushed to the back of the crowd by the showy, imported hangers-on. Rakewell patronizes the arts by collecting gaudily framed continental paintings and employing foreign musicians to entertain him with songs from the latest operas. The acquisition of material property evidently assured Rakewell of his social status; to Hogarth, his creator, the plates to *A Rake's Progress* signified his own exclusive property. Literary and printing pirates had widely copied Hogarth's *A Harlot's Progress* and earned great profit; in order to keep control of *A Rake's Progress,* Hogarth delayed release of Tom Rakewell's saga until the 1735 Engravers' Act, for which he had lobbied, took effect.[69]

69. Paulson 1995, 383–400. The Act was a significant forerunner of the later Copyright Act, and ensured that an image was treated as the property of its maker.

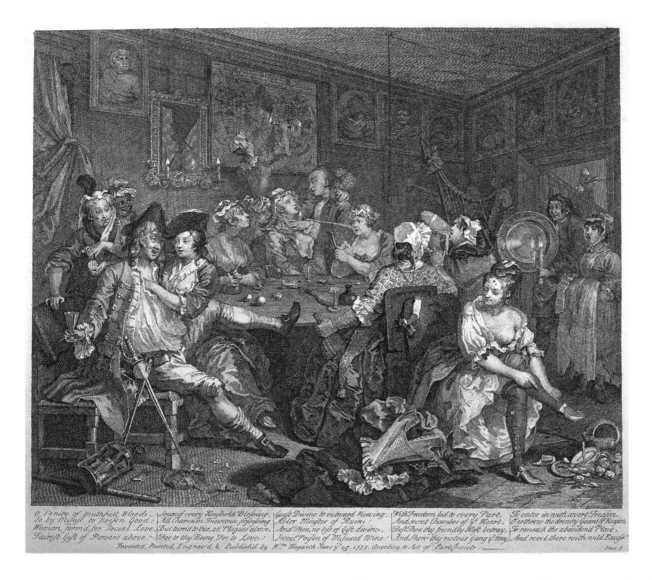

O Vanity of Youthfull Bloods, | Sourse of every Houshold Blessing, | Guest Divine to outward Viewing, | With Freedom led to every Part, | To enter in with covert Treason,
So by Misuse to poison Good: | All Charms in Innocence possessing, | Abler Minister of Ruin! | And secret Chamber of y'. Heart, | O'erthrow the drowsy Guard of Reason,
Woman, form'd for Social Love, | But turn'd to Vice, all Plagues above, | And Thou, no less of Gift divine, | Dost Thou thy friendly Host betray, | To ransack the abandon'd Place,
Fairest Gift of Powers above: | Foe to thy Being, Foe to Love! | Sweet Poison of Misused Wine! | And Shew thy riotous Gang y'. way, | And revel there with wild Excess?
Invented, Painted, Engrav'd, & Publish'd by W'm. Hogarth June y'. 25. 1735. according to Act of Parliment. ——— Plate 3

CATALOGUE 18

William Hogarth

A Rake's Progress

PLATE III, 1735

Etching and engraving, 317 x 383 mm
P. 134, BM Sat. 2188 ii/iii
Collection of Suzanne and Gerald Labiner
TL36700.11

Hogarth parodied the painted conversation pieces popular in France and England. He had painted many himself, capturing the likenesses of the members of an aristocratic family or a gentlemen's social gathering in settings that conveyed their values and wealth. The young rake's aspirations are typified by this sequestered orgy at the notorious Rose Tavern on Drury Lane, identified in the inscription on the engraved metal platter. The viewer, like the pregnant ballad seller or the hunched platter bearer at the door, peeps in as the rake and a friend enjoy the company of ten raucous women. Leather Coat, a real-life character who would allow a cart to run him over in exchange for alcohol, ushers the candle and large dish into the seamy den.[70] These accessories are essential to the dance about to be performed by the sloe-eyed woman who sheds her clothes at the lower right. The members of this dangerous crew united by women's work and men's vapid pleasure have practically destroyed the room and seem to be turning on one another. One harlot spews drink at another, who flashes a blade in retort. Only one pays attention to the rake's comrade, while two others rob the drunken rake who is on the verge of tumbling to the floor. Parallel to his right foot is a small case of pills from a quack apothecary, to ward off venereal disease.

70. Paulson 1970, 164.

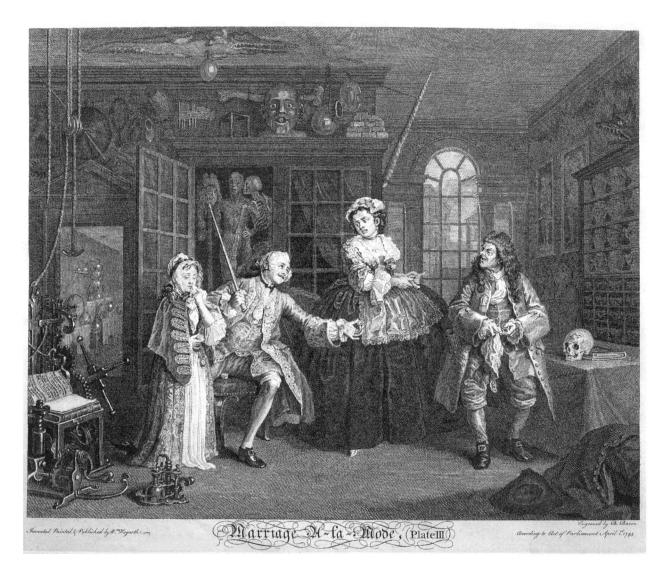

CATALOGUE 19

William Hogarth

Marriage à la Mode

PLATE III, 1745

Etching and engraving, 352 x 449 mm
P. 230, BM Sat. 2717 i/iii
Collection of Suzanne and Gerald Labiner
TL36700.23

Like the carousing protagonist of *A Rake's Progress,* Squanderfield patronizes quack doctors for pills to stave off the ravages of sexually transmitted diseases. The earl gestures toward the doctor with a pill case to implore the doctor for more or stronger tablets for himself and his child prostitute.[71] A prominent silk patch on the earl's neck masks a syphilitic sore, as does the cloth the girl holds to her mouth. A freakish ensemble of equipment and curiosities adorns the room, and a morbid narrative that foreshadows the end of this story unfolds within the shadowy cabinet. The nobleman's upraised cane points toward a disembodied head with a full wig that resembles the kind worn by the corrupt magistrates in Hogarth's print *The Bench* (cat. 14). A tripod that replicates the Tyburn gallows rests atop the cabinet over a naked and preserved male body, perhaps a reference to criminal corpses used in anatomical sessions. A grimacing skeleton, a willful and vulgar emblem of death, gropes the body. These symbols forecast violation, death, a legal judgment, and a body destined for the scaffold and the Barber-Surgeons Company dissection table, prefiguring the resolution apparent in the sixth print from the series (cat. 1).

71. The significance of the two female figures has been debated. An article by Martin Postle convincingly proposes that the girl was originally procured as a cure for the earl's sexual disease and the angry wench is her bawd. Postle 1997, 38–39.

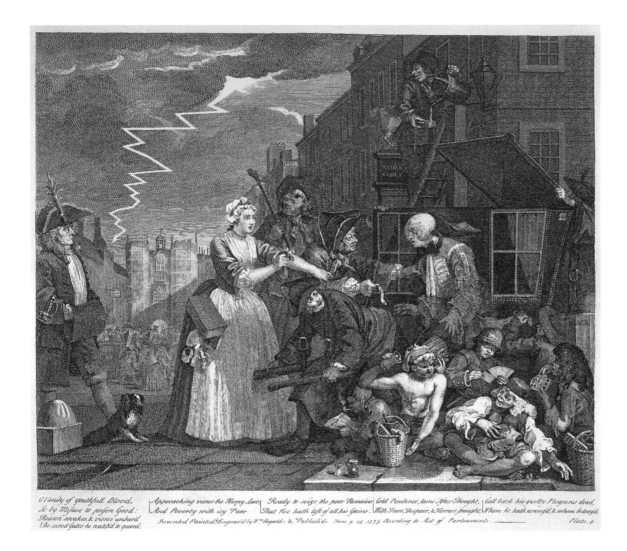

O'Vanity of youthfull Blood, | Approaching views the Harpy Law, | Ready to seize the poor Remains | Cold Penitence, lame After-Thought, | Call back his guilty Pleasures dead,
So by Misuse to poison Good: | And Poverty with icy Paw | That Vice hath left of all his Gains | With Fears, Despair, & Horrors fraught, | Whom he hath wrong'd, & whom betray'd.
Reason awakes, & views unbar'd
The sacred Gates he watch'd to guard.
Invented Painted & Engrav'd by W.m Hogarth, & Publish'd June 9. 25. 1735. according to Act of Parliament. _____ Plate. 4.

CATALOGUE 20

William Hogarth

A Rake's Progress

PLATE IV, 1735

Etching and engraving, 317 x 387 mm
P. 135, B. M. Sat. 2202 i/iii
Collection of Suzanne and Gerald Labiner
TL36700.12

This image illustrates subject matter integral to the process of justice and retribution in Hogarth's stories of deviance, namely the arrest of the protagonist. We also see an arrest in *A Harlot's Progress* (cat. 32) and *The Four Stages of Cruelty* (cat. 38). Gambling and fast living rapidly drain Tom Rakewell's inheritance, and he is arrested for outstanding debts while on his way to White's Chocolate House, a gambling den in the vicinity of St. James's Palace. A bailiff gently explains to Rakewell the charges against him while extending an arrest slip as proof. His burly enforcer props open the door to Rakewell's carriage and obstructs any escape route. One addition to the plate's second state are the dirty, elfin street children who enact a small-scale allegory of the rake's weakness for drink and gaming on the ground near the carriage. Two urchins gamble with playing cards, another form of printed material that Hogarth included in many of his scenes of illicit activity. An arrow-tipped flash of lightning, another detail added in the second state, points to White's and illuminates the muddled action in front of the gambling house. A crowd of the rake's peers and drinking companions have arrived at White's and seem to turn their backs on Tom in his time of trouble. Only the stubbornly loyal Sarah Young materializes to pay off the bailiff on behalf of the man who inherited his father's fortune and then abandoned her, pregnant and heartbroken. The incarceration of debtors of all classes prevented them from dodging creditors or skipping their trial. England's institutionalization of workhouses and prisons for the insolvent during the early modern period grounded the Poor Laws, which degenerated into a stringent system of class regulation in the nineteenth century.

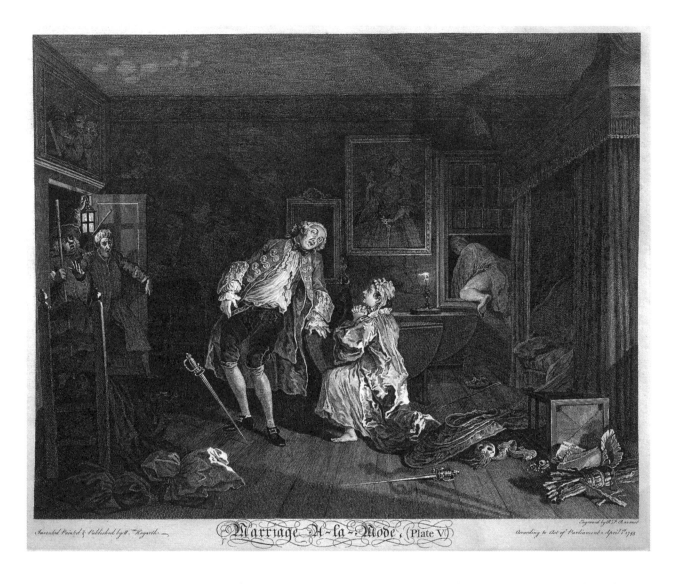

Marriage A~la~Mode (Plate V)

CATALOGUE 21

William Hogarth

Marriage à la Mode

PLATE V, 1745

Etching and engraving, 338 x 448 mm
P. 232, BM Sat. 2744 ii/v
Collection of Suzanne and Gerald Labiner
TL36700.24

The lawyer Silvertongue was a secondary character who flourished in *Marriage à la Mode* as an anti-hero fit for the times. The core of eighteenth-century English law, the sanctity of property, was seriously transgressed in the scenes leading up to this one. Silvertongue had drawn up the contract for the Squanderfields' arranged marriage and then seduced the countess; now he has killed her husband in a duel provoked by the cuckold. His hasty and undignified departure out the window evokes the legendary escapes of Jack Sheppard, the thief who rose to folk-hero status for his many daring breaks from Newgate and who was finally executed in 1724. Reminders of the travesty the Squanderfields made of Christian values and their marriage resonate in the overwrought death scene. In shadow and in light, crosses are cast about the bagnio room as the earl slumps in a deposition-like posture, flanked by his suddenly dutiful Magdalene of a wife. An ornate mirror frames the man's death grimace and provokes viewers of this work to compare the nobleman's ethical choices with their own.

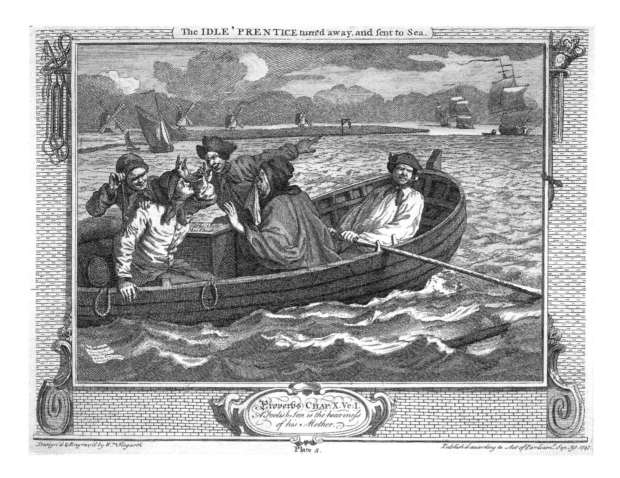

The IDLE 'PRENTICE turn'd away, and sent to Sea.

Proverbs CHAP. X. Ve. 1.
A Foolish Son is the heaviness
of his Mother.

Design'd & Engrav'd by Wm Hogarth Plate 5. Publish'd according to Act of Parliam! Sep. 30 1747.

CATALOGUE 22

William Hogarth

The Idle 'Prentice Turned Away and Sent to Sea

1747

PLATE V from *Industry and Idleness*

Etching with engraving, 254 x 354 mm
P. 172, BM Sat. 2935 i/iii
Collection of Suzanne and Gerald Labiner
TL36700.19

A literary example of Hogarth's being in tune with the vernacular occurs in the ghostwritten autobiography of noteworthy criminal Dennis O'Neale, which was published seven years after the *Industry and Idleness* series. In a description of his illegal activities, the narrator complains that as "I was *industriously* getting Money Abroad, my two foolish Comrades were *idly* spending at home"; he also grumbles that they were bragging to untrustworthy sailors.[72] In Hogarth's *Industry and Idleness* series, Thomas Idle, after a failed career as a weaving apprentice, enters indentured service as a sailor, evident from his work contract adrift in the watery foreground. Symbols in this desolate sea image indicate that brief internment as a sailor will be Idle's last stop before embarking on his doomed criminal career. Arrangements of objects at the vertical edges of the engraved border show implements of torture and restraint on the left and regal emblems of power on the right. Ropes tied like nooses droop over the boat's gunwale, and one of Idle's new shipmates dangles a cat-o'-nine-tails over Idle's shoulder. Mother Idle weeps for her son and he mocks her with a cuckold gesture. Idle's response to his mother's grief indicates that the exposed corpse to which the grimacing sailor points is located on Cuckold Point. Depiction of Idle's banishment to his new ship speaks to the reinstatement of transport as a punishment equivalent to execution early in the eighteenth century. Between 1718 and 1776 Britain shipped over fifty thousand male and female prisoners to penal colonies in America and the Caribbean under the Transportation Act of 1718 and intermittently enforced the condition of death upon their return to England.[73]

72. O'Neale 1754, p. 14. The italic emphasis on *industriously* is from the original text; I added the second emphasis for continuity.

73. Spierenburg 1995, 68.

CATALOGUE 23

Pieter Bast
Netherlandish, d. 1605

Bird's-Eye View of Amsterdam

1597

Engraving, 907 x 809 mm
K. 7
Loan from Robert M. Light
LTL 488.1990
(Not illustrated)

Pieter Bast's 1597 topographical profile of the port of Amsterdam serves as another reminder of the matter-of-fact acceptance of the execution motif in art and the cross-cultural existence of execution spectacles contrived as social control. Sketchy corpses dangle from ropes at the dock gallows in the lower right corner. These executed criminals, most likely meant to represent smugglers or prostitutes who had worked the docks, constitute the greatest concentration of human figures in the image. England and the Northern countries employed hanging as capital punishment and extended the deterrence factor by designating certain fields for the exposure of criminals' corpses, hung in chains until rotted down to the bones.[74] Parallels between Hogarth and Netherlandish artists such as Bast are significant because Hogarth was very aware of Dutch art. Detractors flung accusations of "Dutchness" at Hogarth for his depiction of ignoble drama and everyday scenes, and for his earthy humor. Hogarth despised the revered status granted by collectors and connoisseurs to Dutch and Italian old master paintings over those of contemporary English artists, which made the insulting accusation of "Dutchness" sting all the more.

CATALOGUE 24

William Hogarth

The Reward of Cruelty

1751

Plate IV from *The Four Stages of Cruelty*

Etching and engraving, 356 x 298 mm
P. 190, BM Sat. 3160 i/iv
Collection of Suzanne and Gerald Labiner
TL36700.27

The Reward of Cruelty illustrates the post-execution punishment of murderer Thomas Nero. It is the only instance of Hogarth incorporating in a print a criminal's corpse, which he rendered as the figure with the most expressive face in the composition. The noose still dangles from Nero's neck and the initials marked in gunpowder on his biceps identify his body. Nero's lower-class body functions as an axle to a wheel of detached scientific curiosity, with dissecting students as the spokes, encased by a rim of mingling gentlemen. The linear track of Nero's life, from delinquent orphan to anatomized felon, contrasts with the radial social stratification of the composition and its implication that the upper class has been perpetuating a cycle of brutal social control.

Scottish surgeon William Hunter operated an anatomy school in the 1740s in Coventry Garden and charged a fee for night sessions open to "gentlemen" interested in anatomical exhibitions.[75] Hunter maintained an engraving studio in conjunction with the school, which yielded meticulously accurate prints for educational anatomy texts. Evidence indicates that Hogarth attended one of Hunter's anatomy lessons and drew from the dissection of a pregnant uterus.[76] However, Hogarth's experience with anatomical study must have been limited, judging from the malformed pelvic bones and rib cages of criminal skeletons in the niches. The names over the niches refer to well-known malefactors; the highwayman "Macleane" had been hanged only shortly before Hogarth published this print.

74. Ibid., 50–51. 75. Cazort, Kornell, and Roberts 1996, 85. 76. See Hopkinson 1984, 156–59.

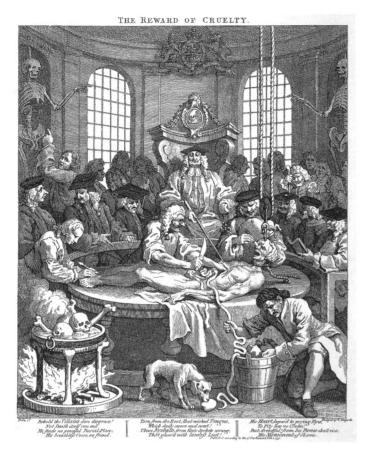

THE REWARD OF CRUELTY.

Behold the Villain's dire disgrace! / Not Death itself can end / He finds no peaceful Burial-Place; / His breathless Corse, no friend. *Torn from the Root, that wicked Tongue, / Which daily swore and curst! / Those Eyeballs from their Spokets wrung, / That glow'd with lawless Lust!* *His Heart, expos'd to prying Eyes, / To Pity has no Claim: / But, dreadful! from his Bones shall rise, / His Monument of Shame.*

24

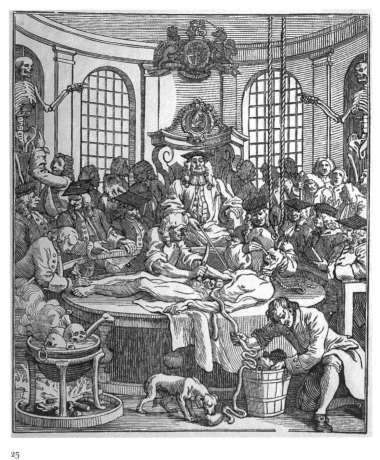

25

CATALOGUE 25

John Bell

English, fl. 1750s

The Reward of Cruelty

after Hogarth, 1750s

Woodcut, 454 x 381 mm
P. 190 Copy, BM Sat. 3167
Collection of Suzanne and Gerald Labiner
TL36700.29

Hogarth proclaimed that a mission of moral edification inspired the inception of *The Four Stages of Cruelty* series. To follow through on his declaration of intended civic education and to make more money by tapping a wider audience, Hogarth authorized the creation of a woodcut edition of the series by John Bell before he published the engraved prints.[77] Like any ambitious eighteenth-century printmaker, Hogarth ran his best-selling plates for as much as they could yield without completely breaking down their lines. The woodcuts were priced lower, and they could be printed in greater number because a woodblock was more durable than a copper plate. However, budget limitations arose and only the final two images in the series, the most gory and sensational, were printed. Their simpler and rougher composition, strikingly translated from the flowing lines of the engraving, invites comparison with woodcut gallows literature. The story was appropriate for a dying speech: a highwayman murdered his family (see cat. 38), he was hanged for the crime, and his body was seized by surgeons for dissection.

77. Quotations pertaining to this intention have already been mentioned. Hogarth 1833, 64–65.

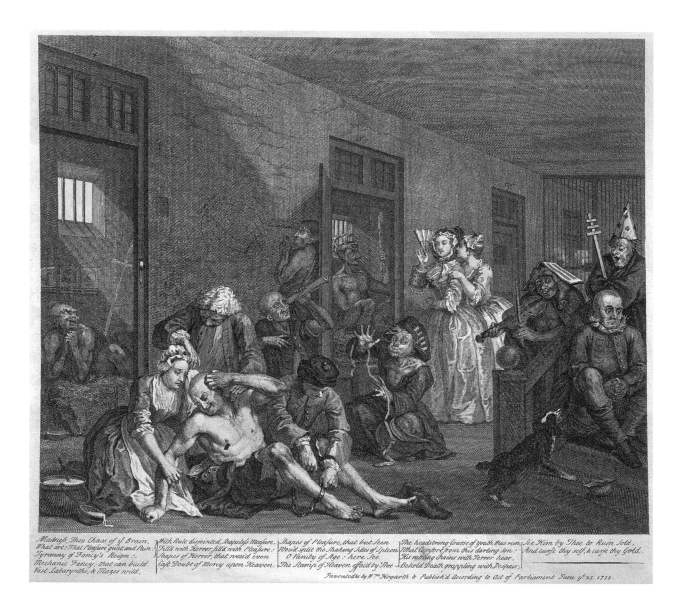

Madness, thou Chaos of y Brain,
What art: That Pleasure givst and Pain:
Tyranny of Fancy's Reign!
Mechanic Fancy; that can build
Vast Labarynths, & Mazes wild.

With Rule disjointed, shapeless Measure,
Fill'd with Horror, fill'd with Pleasure!
Shapes of Horror, that wou'd even
Cast Doubt of Mercy upon Heaven.

Shapes of Pleasure, that but Seen
Wou'd split the shaking Sides of Spleen;
O Vanity of Age : here See
The Stamp of Heaven effac'd by Thee.

The headstrong Course of youth thus run,
What Comfort from this darling Son!
His rattling Chains with Terror hear,
Behold Death grappling with Despair!

See Him by Thee to Ruin Sold,
And curse thy self, & curse thy Gold.

Invented & by W.m Hogarth & Publish'd according to Act of Parliament June y.e 25. 1735.

CATALOGUE 26

William Hogarth

A Rake's Progress

PLATE VIII, 1735

Etching and engraving, 316 x 387 mm
P. 139, BM Sat. 2246 ii/iii
Collection of Suzanne and Gerald Labiner
TL36700.13

The infliction of an ultimate judgment and punishment upon a character in Hogarth's prints was rarely a dignified and private event. The strain of a life colored by alcohol, disease, and bouts of poverty has stripped Thomas Rakewell of his sanity. Without actually illustrating Rakewell's last gasp, the final print in *A Rake's Progress* insinuates that he will expire in Bedlam, a place more dismal than debtors' prison. Hogarth knew that a morsel of grim humor teased from an image of suffering was more entertaining than the stasis of a corpse. The gentlewoman, an emissary of a civilized class and the "modest" sex, stares through a peephole in her fan at the naked madmen. It is unclear whether Hogarth meant to satirize the perversity of a woman ogling a madman—a gender-based inversion of power—or to more generally satirize the people who visited cells at mental wards and prisons as diversion. Shortly before his own death Hogarth reworked this print to insert Britannia, the female symbol for the British Empire, in the circle inscribed by a lunatic on the asylum wall. Britannia's presence metamorphoses the map into a coin that conflates madness, commerce, and Hogarth's perception of England's social climate.

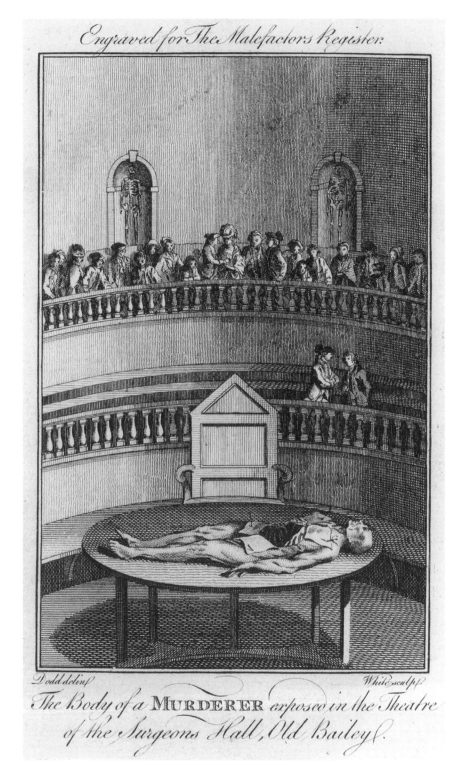

Engraved for The Malefactors Register.

Dodd delin. White sculp.

The Body of a MURDERER exposed in the Theatre of the Surgeons Hall, Old Bailey.

-?- White (?)
English, 18th century

The Malefactor's Register; or, the Newgate and Tyburn Calendar

"The Body of a Murderer Exposed in the Theatre of the Surgeons Hall, Old Bailey," facing p. 168

London, c. 1779

Engraving, 185 x 120 mm
Harvard University Law Library, Rare Book Collection
TL36702.2

The Newgate Calendar was instituted as a tool of moral instruction to document actual examples of criminal activity and to extol the values of civic order realized through proper punishment. Publication of updated volumes continued in the Victorian era, bolstered by the *Calendar*'s popularity as a source of thrilling counterculture tales. Charles Dickens parodied the gap between didactic intention and consumption by thrill-seekers in *Oliver Twist,* when children in Fagin's gang of pickpockets lament that one of their own was arrested but his achievements may not merit record in the *Calendar*. This engraving displays the dissected corpse of a convict with the flesh pinned open in the same type of setting Hogarth depicted in *The Reward of Cruelty* (cat. 24), but in a more documentary manner. This is a scene of ultimate anonymity, isolation, and corporal detachment; the convict's body has been explored and abandoned by the surgeons, and is now ready for disposal in a pauper's grave. It touches on the fear of surgeons held by members of the lower classes, and the reason why some condemned criminals begged for their corpse to be exposed in chains rather than released to the surgeons.[78]

78. Linebaugh 1975, 81.

CATALOGUE 28

William Hogarth

The Company of Undertakers

1737

Etching and engraving, 219 x 178 mm
P. 144, BM Sat. 2299 i/ii
Collection of Suzanne and Gerald Labiner
TL36700.16

In 1737 Hogarth created this false heraldry that cast medical practitioners in the role of killers rather than healers. A black border, usually the frame for a death notification, defines the white coat-of-arms shape. In the lower part of the shield, a clot of twelve "quack-heads" sniff the pomanders housed in the heads of their canes or test urine by tasting it from a flask. The figures hovering above them in the upper deck mock three known "demi-doctors": from left to right, occultist John Taylor, bone-setter Sarah Mapp, and the pill inventor Joshua Ward. Eighteenth-century English doctors and surgeons practiced completely separate occupations, and they were regarded quite differently in literature, drama, and the press. *The Company of Undertakers* gave form to common conceptions of doctors as inept dispensers of questionable remedies. Surgeons, exactly as represented in *The Reward of Cruelty* (cats. 24 and 25), were characterized by members of the lower classes as crazed grave robbers just as willing to vivisect a living person as to carve up a cadaver, driven by bloodlust as much as empirical inquisitiveness.

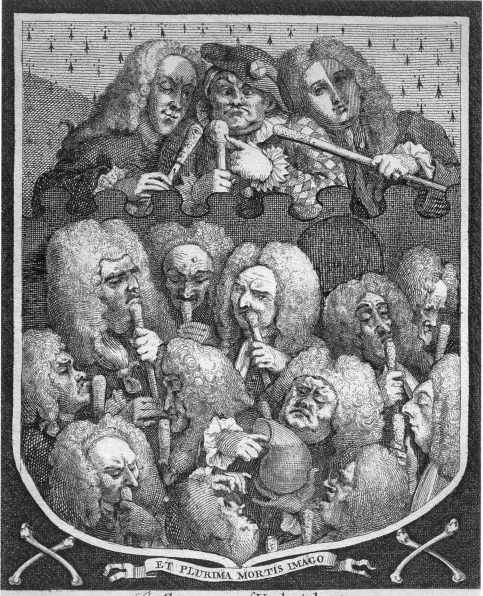

PREDETERMINED SEXUALITY AND "FEMININE" CRIMES

D URING THE SIXTEENTH AND SEVENTEENTH CENTURIES, VERBAL attacks, or "doing execution" to another person, had been regarded as the female equivalent to violent crimes committed by males.[79] This characterization of women as less physically aggressive than men seems to undergo a change in the eighteenth century, when more attention is paid to the violent transgressions committed by women: infanticide, thrill killing, murder in self-defense, torture of servants, husband poisoning, highway robbery, and arson. However, women still did not break the law at the same rate as men, and most of their crimes were motivated by poverty. In London between 1703 and 1772, women accounted for only 92 of the 1,242 people sentenced to hang at Tyburn; of those 92 women, two-thirds had migrated to London, most likely in search of employment.[80] Few of Hogarth's female deviants commit forceful crimes. The majority of them have transgressed the accepted boundaries of proper female sexual behavior; breaches of sexual double standards constituted many of the acts for which women were legally or socially ostracized.[81] In prints Hogarth depicts the inevitable narratives that unfold after women follow a deviant or unconventional route, as in another connotation of *execution* sanctioned by Samuel Johnson: "to do what is planned or determined."[82]

Hogarth frequently depicted the capital crime of prostitution in a titillating manner. The first plate of *A Harlot's Progress* (cat. 29) stages the pivotal moment when a country girl encounters a seemingly kind woman who is actually a bawd hired by an upper-class sexual predator. Standing in the doorway and masturbating beneath his jacket at the sight of Moll Hackabout is the notorious and nonfictional Colonel Francis Charteris, who had a reputation as a seducer and rapist but was only once brought to trial to face charges; he eluded punishment. Countless eighteenth-century English novels dealt with the aftermath of an exploited woman's seduction by a gentleman; a most enduring example is *Moll Flanders*. Daniel Defoe's character influenced Hogarth in the creation of *A Harlot's Progress,* and Moll Flanders persisted to serve Hogarth as an icon of moral debasement in the broadsheet featured in the first plate of his 1747 series *Industry and Idleness* (cat. 30). Unlike *A Rake's Progress* or *Industry and Idleness,* the *Harlot's Progress* series lacks an explanatory textual component: Hogarth let Defoe's words stand.

In *Before* (cat. 31a), from the 1736 set *Before* and *After* (cat. 31a–b), a middle-class girl takes the same moral fall that Moll Hackabout is about to in the first print of *A Harlot's Progress* (cat. 29). One of the comic

touches in Hogarth's 1736 print pair is the facial expression of the post-coitally dazed man who hastily leaves the bedroom. He intends to depart the house undetected and elude the obligation to marry the girl whose physical purity he has just ruined. The family retained the prerogative of forcing a man to marry a woman because he was her first sexual partner, regardless of whether he was a beau or a rapist. The loss of chastity also justified a family ostracizing a female member. Enforcement of a sexual double standard landed many women on the streets and forced them into prostitution.[83]

Premarital sex and prostitution were so scandalous because female sexuality was only sanctioned within the domain of marriage, an institution Eve Tavor Bannet likens to the contemporary legislation precursory to the Engravers' Copyright Act, passed first in 1735. Bannet asserts that women were granted limited social status when legitimized, in effect "copyrighted" by wedlock, as the property of their husband.[84] Only men were granted citizenship and the privileges realized under laws regulating civil, economic, and legal rights. The female body was seen as an extension of the property of father, brother, or husband, and married women retained no child custody rights unless formally given them by the child's father. Young women were not educated about their bodies or sexuality for fear the subject would cause "mental pollution" to the point of derangement.[85] This reinforced the basis of eighteenth-century medical and sexual ideology—that only men should have knowledge about and "access to" women's bodies.[86]

A verbal agreement, sexual intimacy, or having children constituted understood matrimony until Lord Hardwicke's Marriage Act of 1753 redefined wedlock as a legally regulated union. The act outlawed clandestine weddings, which were often conducted in the Fleet Prison, where they required no parental consent, banns, or license.[87] The Act was passed to protect the financial interests of the middle and upper classes; its supporters claimed it shielded young heirs from trickery and protected wealthy single women from bigamists or forced marriages performed under circumstances of abduction.[88] However, the Act may have added to the difficulties of poor women, the class represented in all the Hogarth prints in this section of the catalogue except *Before* and *After* (cat. 31a–b). Stephen Parker has outlined contemporary arguments about the Act's potential to discourage marriage among the lower classes because it required a fee, the four-week waiting period caused reconsideration, and the registry may have intimidated the illiterate.[89]

The most prevalent crime by women in the eighteenth century was minor theft committed after the act of prostitution.[90] Moll Hackabout participates in this statistic in the third plate of *A Harlot's Progress* (cat. 32). Her lowly status as a prostitute and her prowess as a thief are mimicked by the cat; the occasionally affectionate predator strikes a vulgar pose near her bed. The seventh plate of *Industry and Idleness* presents Thomas Idle in bed with his moll as, in a pose similar to Moll Hackabout's in this image, she admires loot stolen from her customers.

References to sexuality and motherhood figure prominently in Hogarth's images of female castigation and suffering. The law had caught up with Moll Hackabout in the third plate of *A Harlot's Progress* (cat. 32), and the pregnant Moll serves a work sentence in Bridewell Prison in the fourth (cat. 33). The crude caricature of magistrate John Gonson dangling from the hangman's gibbet carved upon the wood shutter is a small jab at the lawman known for prosecuting prostitutes.[91] Hanging had been sanctioned for women as a symbolically appropriate death in antiquity, when women, regarded as unworthy of death by the sword, were instead

hanged from trees like unconsumed fruit.[92] Hangmen dreaded the task of killing women, and this led to painfully blundered attempts to execute them. A more private and intimate end, from venereal disease, overcomes Moll in the fifth plate of the series (cat. 34).

Hogarth published *Gin Lane* (cat. 35) and *Beer Street* in 1751 to make a case for the potential social benefits of a tax applied to gin—the strong drink believed to be a destructive epidemic among the lower classes—and not beer. Set in the laboring neighborhood of St. Giles, *Gin Lane* focuses on female susceptibility to drink, and the effects of drunkenness on motherhood. The savage image of drunken women neglecting and killing their babies was in fact based in reality: 12 percent of all women hanged at Tyburn were accused of infanticide (a crime with which only unmarried women could be charged).[93] One woman was arrested for murdering her own child to sell its clothes for gin money.[94] In Gay's *The Beggar's Opera* Lucy Lockit attempts to murder her rival, Polly Peachum, by offering her a tainted tumbler of gin: the drink was so strong that the poison Lockit added would pass undetected. Gin reputedly inflamed the senses and was blamed as the ignition source in the deaths of elderly impoverished women, supposedly by spontaneous combustion. Scholars now believe the women were murdered and burned to obscure evidence of foul play.[95]

Hogarth associated pregnancy with criminal fraud coordinated by a female with a male accomplice. The private sexual "sin" is aligned with public crime, and in each image the trick requires a deceptive performance by the woman. The power relation between the male and female partners indicates the Hanoverian perception of crimes committed by couples: the man made choices, but the woman was coerced or swept along in the action, "vulnerable to total corruption through her sexuality"; even in committing a crime she was a victim.[96] In *A Woman Swearing a Child to a Grave Citizen* (cat. 36a–b), a man prompts his pregnant girlfriend to blackmail a well-to-do man for child-support payments. In *Cunicularii, or the Wise Men of Godlimen in Consultation* (cat. 37), Hogarth could not resist commenting on the supernatural story of Mary Toft from Godalming and the scandal she generated in 1726. Toft claimed to have miscarried a child shortly after becoming obsessed with rabbits she had chased across a field, and that she then "gave birth" to rabbits and animal fragments. The scam was carried out with the hope of making money from the grotesque performance.[97] After Toft's dishonesty was revealed, people testified that her husband had procured small rabbits for the plan.[98]

Although a poor prostitute, Moll Hackabout was more in control of her life than Ann Gill, the fatally vulnerable character in the third plate from *The Four Stages of Cruelty,* titled *Cruelty in Perfection* (cat. 38). The graveyard setting of Ann's murder is an ironic reminder that felons like Thomas Nero were not interred in sacred ground; additionally, it reminds us that land was consecrated as wealth in eighteenth-century England. The ground was no longer considered a suitable medium for the burial of social outcasts or for the termination of female criminals, as it had been in the medieval period when female deviants were returned to the earth by being buried alive.[99] At Tyburn during the Hanoverian period, women convicted of petty treason (murder of a husband) and exceptionally brutal homicide cases were strangled—symbolically and actually separated from earth by hanging—and then reduced to dust and ash by burning. As urbanization gradually absorbed real estate around London, rural land increasingly signified old wealth

and the enclosed domain of the Whig gentry. The portion of the landscape that remained under private aristocratic control was parceled into privatized estates, farmland, and gardens that symbolized man's control over nature. Social mores and legislation that defined women as property and perpetuated sexual double standards were constructed to control and cultivate female fertility as if it were, like land, a commodity.[100]

The Enlightenment preoccupation with finding roots and meanings, and with conquering irrational impulses in order to attain the common good of reason, extended to a systematic reading and manipulating of facial lines and planes by artists in their work. Theoretical inquiries into aesthetics and the nature of beauty abounded in the eighteenth century, and were applied to both women and art. In 1753 Hogarth released *The Analysis of Beauty,* his philosophical treatise on the expressive powers of the line and its ability to evoke certain responses from the viewer. The first of two plates in the book (cat. 39) reveals the undeniable influence of French rococo art on the Francophobic artist's work. Sketches in the isolated boxes framing the image correspond to passages in the text about the curvy and engaging line and its ability to convey a subtext of morality. At the lower right, a man compares images of a nude woman and a flayed female specimen—references to studies of anatomical proportion by Albrecht Dürer and Giampolo Lomazzo—to the central female statue in the fantastic courtyard.[101]

The most remarkable eighteenth-century anatomical study made after a woman was recorded in Robert Strange's exquisite engravings of a pregnant human uterus (cat. 40) for a folio authored by Dr. William Hunter. This image originated in a public dissection where Hunter peeled away the concealing layers of flesh to teach others about the uterine structure and fetal formation. Condemned women were subject to dissection under the 1752 Murder Act, just as men were. The hanging of a female felon was further sensationalized by the added humiliation of allowing the crowd a view up the dress; dissection allowed complete manipulation.

During the eighteenth century, "new ways of imagining women" appeared in art and novels that featured female protagonists. Hogarth refined female criminal portraiture in his image of *Sarah Malcolm* (cat. 41).[102] In 1732 the Irish laundress was accused of robbing her employer, the elderly Lydia Duncomb, strangling both Duncomb and a servant, and then cutting the throat of Duncomb's teenage maid. Malcolm was only twenty-two when she stood trial, and the three people she identified as participants in the theft and the actual murderers were all released. Hogarth quickly produced a print of Malcolm to sell before her 1732 execution. He profited from it greatly on account of London's passionate fascination with the young and beautiful condemned criminal.

In comparison with Hogarth's psychological portrait of Sarah Malcolm, an anonymously published image of Malcolm's hanging (cat. 42) resembles amateur street literature. This image was included in a collection of stories about high-profile malefactors "Interpreted with several diverting TALES, and pleasant SONGS," and accompanied a transcription of Sarah Malcolm's final letter.[103] The engraver's attempt to render an active crowd and the charged atmosphere of the execution reveals Hogarth's influence, but the depiction of Malcolm in her final moments with a noose around her neck is more in key with sensational street literature.

Hogarth himself was not immune from accusations that he acted as judge and punisher by satirizing his fellow humans in art. One year before the artist's death, Charles Churchill attempted to "do execution" to Hogarth through a lengthy poem. Churchill characterized the intent behind Hogarth's art as the malicious manipulation of graphic media into a dangerous space analogous to the scaffold: "Hogarth, a guilty pleasure in his eyes, / The place of Executioner supplies."[104]

79. The phrase "to do execution" was from Johnson 1755, 8M2r. Conceptions of "female" and "male" crime are discussed in Kermode and Walker 1994, 5.

80. The number of women hanged is from Gatrell 1996, 8. Demographics are from Linebaugh 1991, 142–43.

81. The social ostracism of women for acts men committed freely is raised in Browne 1987, 4. I include "legally" because of the prevalence of prostitution in the eighteenth century. As Peter Linebaugh has suggested, in the eighteenth century the term *prostitution* could refer to a variety of acts. Linebaugh 1991, 145.

82. Johnson 1755, 8M1v.

83. The unequal penance for sexual activity outside of marriage is discussed in Browne 1987, 4–5.

84. Bannet 1997, 236.

85. Jarrett 1976, 116.

86. Mendelson and Crawford 1998, 18–21.

87. Parker 1990, 34–37.

88. The protection of property figured so significantly in the law that a woman who killed a relative was punished more severely in court than a jilted one who murdered her lover. Inheritance of family wealth was thought to encourage crime between kin. McLynn 1989, 118.

89. Parker 1990, 45.

90. Ibid., 125.

91. Paulson 1970, 146–47.

92. Naish 1991, 81–82.

93. Statistic from Linebaugh 1991, 148. Information on infanticide in McLynn 1989, 110.

94. Uglow 1997, 495.

95. Shaw 1995, 1–22.

96. Alice Browne makes this statement using the impending meeting between Moll and Charteris, the first plate from Hogarth's *A Harlot's Progress* series (cat. 29), as an example. Browne 1987, 60.

97. Uglow 1997, 120.

98. From depositions made by Ed Costen and Richard Stedman and published in *The Several Depositions* 1727, 3–7.

99. Naish 1991, 82.

100. The social order depended on the direction of female sexuality toward reproduction. Mendelson and Crawford 1998, 21.

101. Paulson 1970, 222.

102. Browne 1987, 13.

103. From the title page of Johnson 1734.

104. Churchill 1763, 16.

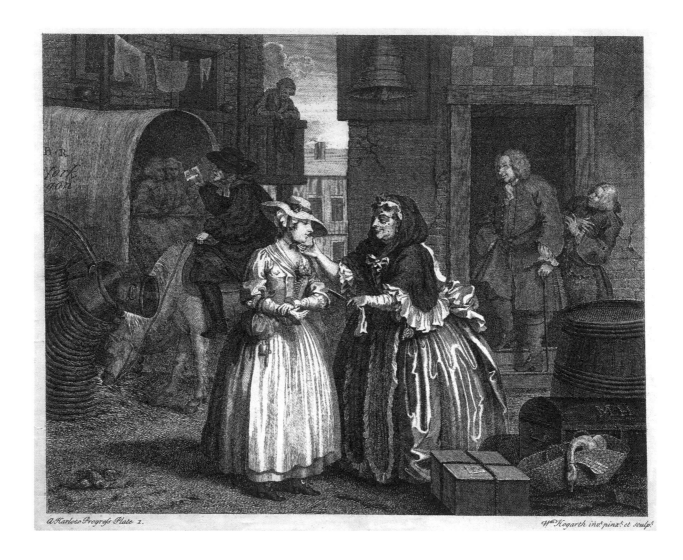

CATALOGUE 29

William Hogarth

A Harlot's Progress

PLATE I, 1732

Engraving, 300 x 374 mm
P. 121, BM Sat 2031 i/iv
Collection of Suzanne and Gerald Labiner
TL36700.4

A woman's virtue was the cornerstone of the eighteenth-century ideology of female sexuality. The gullible rural girl searching for legitimate labor but ending up as a prostitute was a conventional archetype in Hanoverian art, and was specifically formulated to wrench the hearts of mothers and fathers.[105] Hogarth tapped directly into this anxiety in *A Harlot's Progress*. The first plate shows the initiation of a chain of events leading inevitably to sin and the ruin of Moll Hackabout. Moll arrives in London with sewing kit in hand and the gift of a dead goose for her cousin. Alas, she is set upon by a procuress, Mother Needham, who sees profit when gazing into Moll's fresh face; the bawd's touch damns Moll's future. The real Elizabeth Needham was arrested for running a well-known brothel and sentenced to time in the pillory. A rowdy crowd, some known to her as customers, approached and pummeled the old woman to death.[106]

The character Moll Hackabout and her printed escapades were Hogarth's property, but their great success spawned numerous plagiarisms varying from the clever to the blatantly pornographic. Hogarth avenged these piracies by instigating the Engravers' Copyright Act of 1735, which was frequently called "Hogarth's Act" for his role in spearheading its passage.[107]

105. Jarrett 1976, 86. 106. Paulson 1995, 382. 107. Ibid., 386–87.

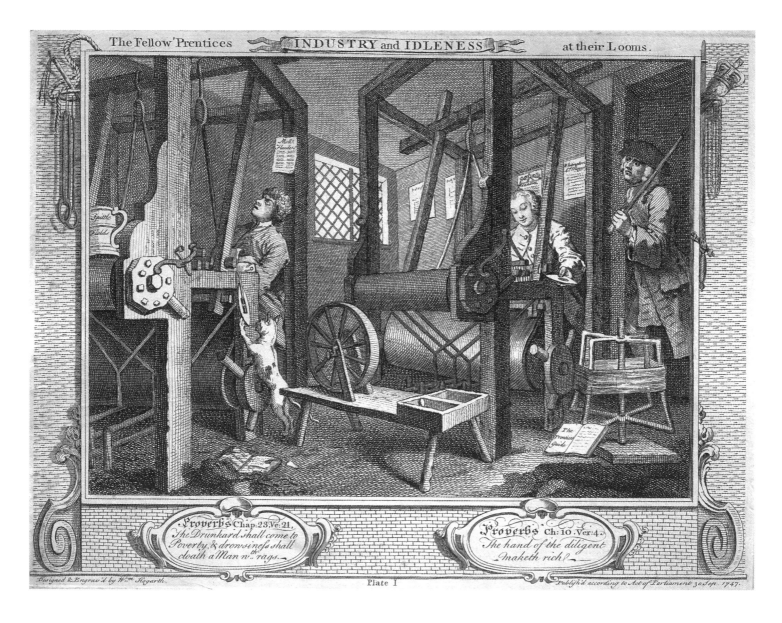

CATALOGUE 30

William Hogarth

The Fellow 'Prentices at Their Looms

Plate I from *Industry and Idleness*
1747

Etching with engraving, 259 x 340 mm
P. 168, BM Sat. 2896 ii/ii
Collection of Suzanne and Gerald Labiner
TL36700.18

Although members of all classes purchased popular reading materials, novels and broadsides were regarded as agents of corruption for sentimental women and laborers like the fictional slack apprentice Thomas Idle. Hence, the title sheet from Daniel Defoe's 1722 novel *Moll Flanders* pinned up next to Idle's loom declares his class, his sloth, and his inclination toward deviance. It contrasts sharply with the chapbook image above Francis Goodchild's head, *The London Apprentice,* which shows a young and stout apprentice who virtuously fends off two lions without using weapons.[108] Hogarth's inclusion of Moll Flanders, harlot and pickpocket extraordinaire, foreshadows Idle's weakness for women, and the company he will soon keep. As an object within the image, the sheet from *Moll Flanders* evokes both the audience for bawdy literature and the prevalence of printed material. Furthermore, the penetration of this sheet into the work environment occupied by a low-life character suggests the vision Hogarth had for much of his own didactic material: to invade the imaginations of those in need of moral guidance and to spark self-examination.

108. Identified in Wind 1997, 239.

CATALOGUE 31a

William Hogarth

Before

1736

Etching and engraving, 373 x 303 mm
P. 141 i/iii
Collection of Suzanne and Gerald Labiner
TL36700.14

CATALOGUE 31b

After

1736

Etching and engraving, 370 x 305 mm
P. 142 i/iii
Collection of Suzanne and Gerald Labiner
TL36700.15

A market existed for pornographic prints of London's seamy underside, the culture of the laboring class; this genre included scenes of seduction or of harlot pairs robbing drunken patrons. Hogarth painted two versions of *Before* and *After* in 1736 as commissions; these prints differ from the painted works but similarly depict the build-up and aftermath of a clumsy first sexual encounter. The contrast in the prints highlights the struggles before and after sex but skips the understood middle transaction. In the first scene the dog's excitement mimics the man's, and a mischievous putto ignites the fuse of a large firecracker in the image on the wall. The anxious woman upsets a bureau while squirming away from the eager man's grasp. Hogarth assigns responsibility for avoiding sexual peril to the woman by showing the objects that spill from the drawer: a volume titled *The Practice of Piety,* which she apparently neglected in favor of romantic literature, and folded love notes, which she has accepted. In the second print, the man dresses quickly while the woman clings for fear of abandonment; unwed pregnant women were ostracized and classed as visibly "ruined" goods.

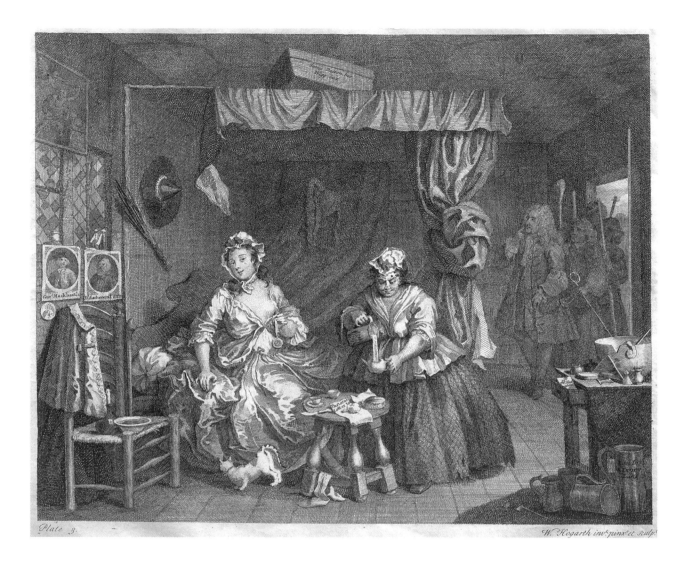

CATALOGUE 32

William Hogarth

A Harlot's Progress

PLATE III, 1747

Engraving, 300 x 374 mm
P. 123, BM Sat. 2061 i/iii
Collection of Suzanne and Gerald Labiner
TL36700.5

Moll Hackabout quickly tumbled from the tenuous but comfortable status of a kept woman to that of a common harlot in the seamy Drury Lane district, as indicated by the inscribed vessel in the lower right. In this plate, Moll proudly dangles a fine watch that she recently lifted from a wealthy customer. Pocks on her face reveal the presence of venereal disease, and her servant's disfigured nose demonstrates the ravages of syphilis. References to real and fictional criminals indicate that Moll now runs with a dangerous crowd and cannot sink much further. Next to the bed hangs a picture of John Gay's highwayman hero Captain "Mackeath," and a wig box over the bed is inscribed with the name of a notorious criminal, James Dalton. Led by Magistrate Gonson, a band of constables intent on arresting Moll for prostitution enters the dingy private quarters with seeming curiosity about Moll's occupation.

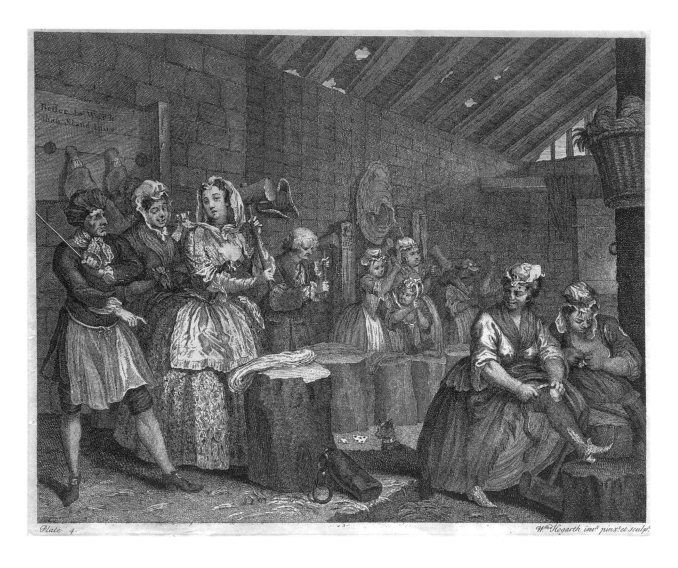

CATALOGUE 33

William Hogarth

A Harlot's Progress

PLATE IV, 1732

Engraving, 302 x 379 mm
P. 124, BM Sat. 2075 i/iii
Collection of Suzanne and Gerald Labiner
TL36700.6

Moll Hackabout, glittering in her inappropriate finery in jail, beats hemp for the hangman's rope. Art historians have consistently attributed Moll's bloated and flabby appearance in this print to symptoms of venereal disease and aging. However, a very pregnant woman stands down the line of convicts from Moll and in the next print from this series Moll has a child. It would follow that here Hogarth was punning on Moll serving a sentence of "labor." Also, the previous plate's shabby image of an angel halting Abraham's sacrifice of Isaac indicates an intervention in the law to spare a child. Did Moll Hackabout, unlike her procreant literary sister Moll Flanders, honestly "plead her belly" to delay her capital sentence or receive a lighter one? Condemned female prisoners were allotted a certain amount of time to prove, if necessary, that they were with child. If not pregnant at the time, temporary exemption from execution brought by "pleading the belly" was reason enough to try to get pregnant immediately. Affirmed pregnancy would mean a delayed sentence in the eighteenth century, but not necessarily a repealed one; in the seventeenth century, however, the pregnant felon could have been branded or whipped instead of hanged after the birth.[109]

109. Mendelson and Crawford 1998, 46–47.

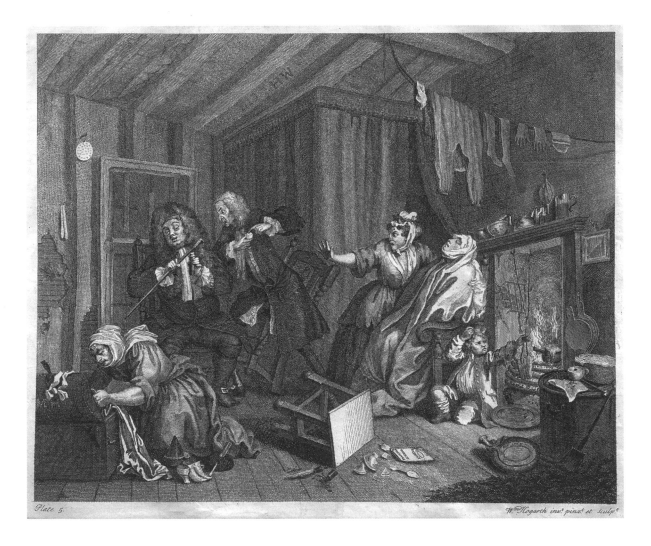

CATALOGUE 34

William Hogarth

A Harlot's Progress

PLATE V, 1732

Engraving, 305 x 374 mm
P. 125, BM Sat. 2091 i/iii
Collection of Suzanne and Gerald Labiner
TL36700.7

The penultimate plate to *A Harlot's Progress* presents the final physical, as opposed to economic and social, decline of Moll Hackabout. Two quack doctors pay her a house call and disagree about who made a better cure for venereal disease, although Moll's consumption of the remedies may have accelerated her death. The image is analogous to Squanderfield's visit to the apothecary in the third plate of *Marriage à la Mode* (cat. 19). Hogarth was familiar with the manufacture of remedies because his mother, Anne, contributed to the household income by selling medicinal supplements out of their house.[110]

One subordinate story line in this dismal image is the impending fate of Moll's newly orphaned son. In 1722 concern about the rate of infanticide and the numerous children abandoned in London's streets provoked the wealthy shipbuilder and philanthropist Thomas Coram to begin working toward toward establishment of the Foundling Hospital, which opened in 1741.[111] There, women drew lots to leave their illegitimate babies or children for whom sustenance was too difficult to provide. The idea of the Foundling Hospital drew disapproval from aristocratic women who were alarmed that an institution assisting bastard infants would encourage promiscuity; they declined support for it. Hogarth served on the hospital's board of directors in the 1740s, although as much to cultivate the halls into exhibition spaces as to express his concern for endangered children.

110. Uglow 1997, 26. 111. The process of establishing the Foundling Hospital is described in ibid., 329–30.

CATALOGUE 35

William Hogarth

Gin Lane

1751

Etching and engraving, 361 x 305 mm
P. 186, BM Sat. 3186 iii/iv
Collection of Suzanne and Gerald Labiner
TL36700.21

In Hanoverian London cheap gin had earned recognition as a crutch for the destitute, particularly old women and whores.[112] A pamphlet published anonymously in 1790, *An Explanation of the Vices of the Age,* promised to elucidate the "intrigues of lewd women" and named gin a "wicked slut" capable of inducing "rage" in any woman.[113] Another author, responding to Hogarth's *Gin Lane,* vouched that when "a Woman accustoms herself to Dram-drinking, she generally becomes the most miserable as well as the most contemptible Creature upon Earth."[114] In the image Hogarth emphasizes the ravages of the supposed female disposition toward gin addiction and its aftermath in relation to working-class motherhood. An exposed infant slips from the arms of his drunken mother as she reaches for her tobacco, and a dancing sot skewers a baby in the center background. Two very young girls wearing the uniform of the St. Giles orphanage sip gin at the center right, indicating that they are on the path to whoredom. Hogarth must have hastily engraved the plate from his working drawing because he forgot to reverse the "S. G." on one girl's arm patch. The drink itself is feminized at the lower left in the skeletal ballad seller's product, a sheet titled "The downfall of Madam Gin." In the upper right a hanged figure is suspended from the rafters of a dilapidated building, driven suicidal by gin madness. This visual link between hanging and alcohol registers drunkenness both as a vice and as its own punishment for vice, comparable to Hogarth's treatment of sexually transmitted diseases in other prints.

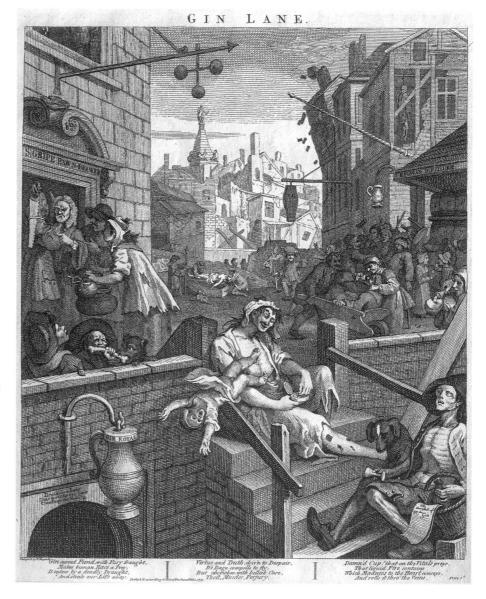

GIN LANE.

112. A concise description of gin's history in London and the importance of *Gin Lane* to the passage of Henry Fielding's Gin Act is in ibid., 493–94.

113. *An Explanation of the Vices of the Age* 1790, 4.

114. *A Dissertation on Mr. Hogarth's Six Prints Lately Publish'd* 1751, 11.

CATALOGUE 36a

Joseph Sympson, Jr.
English, fl. 1724–36

Woman Swearing a Child to a Grave Citizen

after Hogarth, 1735

Etching and engraving, 256 x 336 mm
P. 334, BM Sat. 2261
Collection of Gerald and Suzanne Labiner
TL36700.31
(Not illustrated)

CATALOGUE 36b

Woman Swearing a Child to a Grave Citizen

after Hogarth, 1735

Copper plate, 256 x 336 mm
Collection of Gerald and Suzanne Labiner
TL 36545
(Not illustrated)

This print was made after a Hogarth painting, in this case not by Hogarth himself but by the son of a popular London reproductive engraver. The iconography represents a conventional Hanoverian perspective on crimes committed by a team of man and woman. The meek-looking girl, encouraged by a sly young man at her elbow, swears that the outraged middle-class man fathered her unborn child. Ignoring any protestations lodged by the accused man, the presiding magistrate seems unmoved and refers to the "Law of Bastardry" in front of him. The perpetrators of this extortion scheme are mimicked by the child sitting next to the podium who teaches her dog to dance on command. Hogarth's representation of pregnancy as a tool for deception also gave visual form to the rationale behind laws established at the middle of the century to clarify paternity and inheritance. The print dates to 1735 but addresses anxieties codified in the Marriage Act of 1753, written to protect familial wealth from rogues and to prevent illegitimate children from being recognized as heirs.

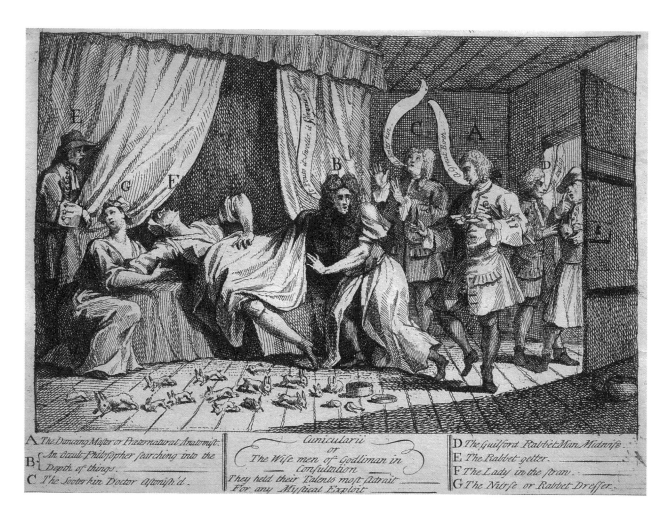

A The Dancing Master or Praeternatural Anatomist.
B { An Occult Philosopher searching into the Depth of things.
C The Sooterkin Doctor astonish'd.

Cunicularii
or
The Wise men of Godliman in
Consultation
They held their Talents most adroit
For any Mystical Exploit.

D The Guilford Rabbet-Man Midwife
E The Rabbet-getter.
F The Lady in the straw.
G The Nurse or Rabbet Dresser.

CATALOGUE 37

William Hogarth

Cunicularii, or the Wise Men of Godlimen in Consultation

1726

Etching, 160 x 240 mm
P. 107, BM Sat. 1779 i/ii
Collection of Suzanne and Gerald Labiner
TL36700.3

The Mary Toft rabbit-breeding affair cast doubt on many midwives' knowledge of pregnancy, which was crucial to the fate of many female criminals. It called into question their ability to judge whether women who "pleaded the belly" were actually pregnant and, in cases of suspected infanticide, if the child was born dead or killed after birth.[115] In this print Hogarth made sport of Toft and ridiculed the high-minded doctors who fell for her phantasmagoric show. The horizontal band of figures recounts a condensed version of Toft's story. Toft sprawls on a bed that appears much like a stage, with curtains parted in a manner analogous to her skirts, while she passes whole and partial fleeing rabbits. She was the subject of medical inquiries into the influence of the impressionable mind over the pregnant body; if this old myth had been legitimized through Toft, it would have followed that malformed or illegitimate pregnancies were punishment for indulgence in impure thoughts. Physical examinations and popular scrutiny forced Toft to confess that collaborators, shown here at the door sharing secretive gestures, provided her with animal bits which she expelled at staged moments. A pamphlet published in 1727 that claimed to be "a Full and Impartial Confession from her own Mouth" quoted Toft as wishing that the public would "piti me, and not se me hangid" for her fraud.[116]

115. Browne 1987, 16.

116. *Much Ado about Nothing: or, a Plain Refutation* 1727, 21.

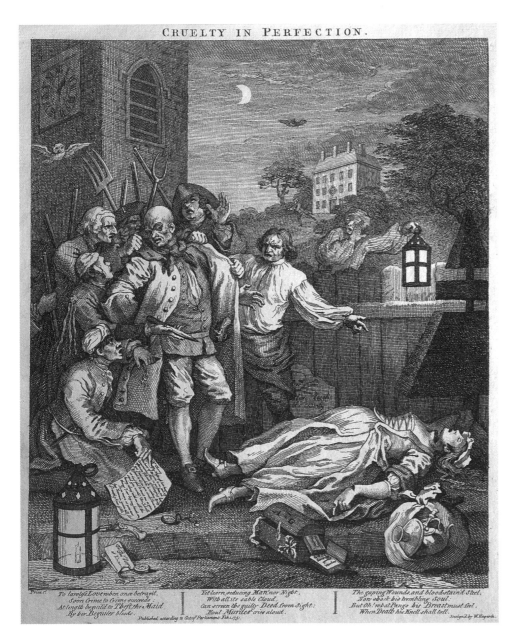

CATALOGUE 38

William Hogarth

Cruelty in Perfection

1751

Plate III from *The Four Stages of Cruelty*

Etching and engraving, 356 x 298 mm
P. 189, BM Sat. 3159
Collection of Suzanne and Gerald Labiner
TL36700.26

The circumstances of the abused female character in *The Four Stages of Cruelty,* Ann Gill, vary only slightly from those of Moll Hackabout from *A Harlot's Progress* or the milkmaid murdered by John Clarke (cat. 2). Ann makes her sole appearance in the series in her own death scene, blood flowing from her neck like a ribbon that replicates the shape of her hair. Thomas Nero, apparently a highwayman, judging from his pistols and the loot spilling from his pockets, killed Ann and their unborn child. A letter written by Ann and removed from Nero's possession reveals that the young servant had stolen the bundle of silver from her good mistress. A phallic knife at Nero's hips points to Ann's round belly to verify his role in her pregnancy. By committing murder, Nero desired to erase his responsibility for impregnating Ann and prompting her to perpetrate the theft. Ann's vulnerability and silence are further exaggerated by the extreme violence done to her body. The gaping wound in her neck and the slice that nearly detached her first finger prevented her from implicating Nero by voice or a pointing gesture. Hogarth leaves the larger responsibility for Ann's demise ambiguous. Nero undeniably seduced and murdered Ann, but a magistrate would not have been moved by the fact that she committed theft—a capital crime—for love.

CATALOGUE 39

William Hogarth

The Analysis of Beauty

PLATE I, 1753

Etching and engraving, 372 x 500 mm
P. 195, BM Sat. 3217 iii/iii
Collection of Suzanne and Gerald Labiner
TL36700.28
(Not illustrated)

Hogarth devoted the fifteenth chapter of *The Analysis of Beauty* to his method of rendering beauty or coarseness in "The Face." He favored manipulation of a "serpentine" line to create interest through "intricacy" rather than the bland "symmetry" of proportionally devised classical sculpture.[117] Hogarth's theory is directly apparent in his preoccupation with capturing physiognomy and the surface qualities in portraits of women and criminals. In reading a face, the artist noted "how are our eyes riveted to the aspects of kings and heroes, murderers and saints; and as we contemplate their deeds, seldom fail making application to their looks."[118] He continued to observe that "the character of an hypocrite is entirely out of the power of the pencil" because one must render him "as smiling and stabbing at the same time."[119] Hogarth's contemplation of "saints and murderers" provokes consideration of how he depicted female delinquents. Women were regarded as naturally being morally superior to men, but committing a crime indicated defective character; this paradox is exemplified in Hogarth's 1732 portrait of Sarah Malcolm (cat. 41).

In *The Analysis of Beauty*, the artist expressed his distaste for antiquities in the laureled classical statue in the right middleground, tied off by a rope knotted around the neck like a noose. On the funerary monument at the right, a weeping putto sits with a judge and holds a gibbet-shaped carpenter's square.[120]

CATALOGUE 40

Robert Strange
English, 1721–1792

The Anatomy of the Human Gravid Uterus Exhibited in Figures, by William Hunter... (Anatomia Uteri Humani Gravidi Tabulis Illustrata, Auctore Gulielmo Hunter...)

"Plate VI. This Represents the Child in the Womb, in its Natural Situation (Tabula VI. Foetus in Utero...)"

London, 1774

Engraving, 584 x 440 mm
Francis A. Countway Library of Medicine, Harvard University
M.191.35
(Not illustrated)

Dissection of a woman was uncommon in the anatomists' theaters of the eighteenth century, and a public and above-the-board dissection of a pregnant cadaver was even rarer. The accepted and legal route for anatomists to obtain a corpse after 1752 was at Tyburn, and the female criminal could in some cases dodge execution by pleading pregnancy. Because dissection violated the body and was inconsistent with a proper Christian burial, few pregnant bodies were offered or could be purchased from the family. Gruesome accounts from the seventeenth century tell of overeager surgeons taking away the bodies of women hanged for infanticide before the women were truly dead; the women would revive and then be taken back to the gallows and hanged again.[121]

Beginning in 1751 (the year before the Murder Act decreed the release of bodies of hanged criminals for dissection), Dr. William Hunter dissected a series of pregnant bodies and "every part was examined in the most public manner."[122] The vivid red chalk drawings made from these sessions were engraved by Robert Strange and published as a folio in 1774. Also drawing at one of the earlier sessions was William Hogarth. In a lecture, Hunter recalled that Hogarth had expressed awe at the clear and logical design of the uterus, and then made a fine drawing of it.[123] It is not known what happened to that drawing, but Hogarth had regularly incorporated pregnancy into narratives of female morality.

117. The three words I quoted here appear throughout Hogarth 1997.
118. Ibid., 95–96.
119. Ibid.

120. This detail is noted in Paulson 1970, 222.
121. Sawday 1995, 220.
122. Hunter 1774, column 1, paragraph 4 of the "Preface."
123. Hopkinson 1984, 156–59.

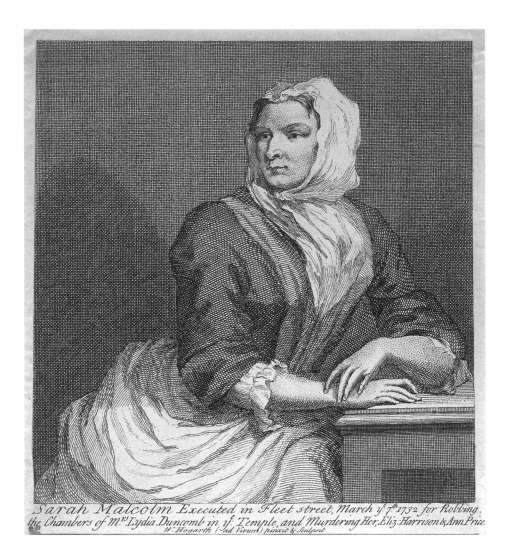

Sarah Malcolm Executed in Fleet street, March y.7ᵗʰ 1732 for Robbing the Chambers of Mᵣˢ Lydia Duncomb in yᵉ Temple, and Murdering Her, Eliz. Harrison & Ann Price.
W. Hogarth (ad Vivum) pinxit & sculpsit.

CATALOGUE 41

William Hogarth

Sarah Malcolm

1732

Etching and engraving, 175 x 165 mm
P. 129, BM Sat. 1907 i/i
Collection of Suzanne and Gerald Labiner
TL36700.8

Eschewing racy or sensational details, Hogarth's focus on Sarah Malcolm's physiognomy directs the viewer to consider Malcolm as a strong woman accused of murder and not as a crafty strumpet. A preoccupation with Malcolm's physical bearing permeates Hogarth's image. Her broad shoulders and solid arms indicate her laboring-class status but her hands, the implements of the alleged murder, are posed in a graceful and feminine manner. He rendered her attractive and yet swore to read in her visage that she was "capable of anything."[124] Intimate details of Malcolm's body also figured prominently in her trial. Stolen coins wrapped in her hair implicated her as a participant in the theft. A straight razor and a shift found in her possession, which Malcolm claimed was stained by her menstrual blood and not the blood of the murder victims, sealed her conviction.[125] Subsequent to Malcolm's execution in 1732, Hogarth included a knife-wielding female character in the 1735 series *A Rake's Progress* (cat. 18) and in *Marriage à la Mode* (cat. 19), published in 1745. From Newgate, Malcolm specially ordered a shroud and a pair of drawers to prevent people from looking up her dress during her hanging. Crowds visited Malcolm's corpse after the hanging, and the shroud proved unnecessary because eventually she was dissected. The final destination of her skeleton was a glass exhibition case in the Botanical Gardens at Cambridge.[126]

124. Uglow 1997, 232. 125. Paulson 1992, 8. 126. British Museum, Department of Prints and Drawings 1870–1954, 774.

CATALOGUE 42

Maker Unknown
English, 18th century

A General History of the Lives and Adventures of the Most Famous Highwaymen, Murderers, Street-Robbers, &c.

"The Execution of Sarah Malcolm in Fleet = Street,"

facing p. 483

London, 1733/34

Engraving, 295 x 200 mm
The Houghton Library, Harvard University, Donation Fund, 1847
*f EC7 J6308 733ga
(Not illustrated)

Hogarth's success and style influenced the work of other engravers who also captured the events of contemporary London in their prints. This engraving of Sarah Malcolm relies on a staple format of sensational broadsides, the final moments of a convict's life before the wild crowd. Malcolm stands in the cart that has conveyed her through the horde to the gibbet and is to function as a scaffold; she would be hanged on Fleet Street across from Mitre Court, and not at Tyburn. The hangman prepares to slip a hood over her head as she reads from a Bible, an accessory that alludes to her in-prison conversion to Catholicism. The unnatural perspective demonstrates the artist's desire to obscure the inept rendering of the human figure. Half the composition is expended in bland sky; more space is wasted on a long, lumpy foreground and the sea of uniform bumps meant to evoke heads. In an unsuccessful attempt at Hogarthian human interest, two men at the left, one bald and wearing a long jacket evocative of Hogarth's many inclusions of the popular pugilist James Figg, take swings at each other.

BIBLIOGRAPHY

A Dissertation on Mr. Hogarth's Six Prints Lately Publish'd, viz. Gin-lane, Beer-street, and the Four stages of Cruelty. 1751. London.

An Explanation of the Vices of the Age. Wherein is Explained, the Knavery of Landlords, the Imposition of Quack-Doctors, the Roguery of Pettyfogging Lawyers, the Cheats of Bum-Bailiffs, and the Intrigues of Lewd Women. 1790. London.

Bannet, Eve Tavor. 1997. "The Marriage Act of 1753: 'A Most Cruel Law for the Fair Sex.'" *Eighteenth-Century Studies* 30.3:233–54. http://muse.jhu.edu:80/journals/ eighteenthcentury_studies/v030/30.3bannet.html.

Bindman, David. 1992. "The Nature of Satire in the Modern Moral Subjects." In *Image et société dans l'oeuvre graphique de William Hogarth: Actes du colloque tenu a l'Université de Paris X-Nanterre, le 11 janvier 1992,* edited by Frédéric Ogée. Nanterre.

———. 1997. *Hogarth and His Times: Serious Comedy.* Exh. cat., Berkeley Art Museum, University of California, Berkeley.

Brewer, John. 1986. *The Common People and Politics, 1750–1790s.* The English Satirical Print, 1600–1832. Alexandria, Va.

British Museum, Department of Prints and Drawings. 1870–1954. *Catalogue of Prints and Drawings in the British Museum. Division I: Political and Personal Satires. 1689–1733.* Vol. 2. London.

Browne, Alice. 1987. *The Eighteenth-Century Feminist Mind.* Sussex.

Caulfield, James. 1819–20. *Portraits, Memoirs, and Characters, of Remarkable Persons, from the Revolution in 1688 to the End of the Reign of George II.* Vol. 4. London.

Cazort, Mimi, Monique Kornell, and K. B. Roberts. 1996. *The Ingenious Machine of Nature: Four Centuries of Art and Anatomy.* Exh. cat., National Gallery of Canada, Ottawa.

Churchill, Charles. 1763. *An Epistle to William Hogarth.* London.

Clayton, Tim. 1997. *The English Print 1688–1802.* New Haven.

Dolan, Frances E. "'Gentlemen I Have One More Thing to Say': Women on Scaffolds in England, 1563–1680." *Modern Philology* 92:167–78.

Gatrell, V. A. C. 1996. *The Hanging Tree: Execution and the English People 1770–1868.* New York.

Gay, John. 1986. *The Beggar's Opera,* edited by Bryan Loughery and T. O. Treadwell. New York.

Gilmour, Ian. 1992. *Riot, Risings, and Revolution: Governance and Violence in Eighteenth-Century England.* London.

Godfrey, Robert. 1984. *English Caricature, 1620 to the Present: Caricaturists and Satirists, Their Art, Their Purpose and Influence.* Exh. cat., Victoria and Albert Museum, London.

Gomme, George Laurence. 1909. *Tyburn Gallows.* London.

Hay, Douglas. 1975. "Property, Authority and the Criminal Law." In *Albion's Fatal Tree: Crime and Society in Eighteenth-Century England,* edited by Douglas Hay, Peter Linebaugh, John G. Rule, E. P. Thompson, and Cal Winslow. New York.

Hogarth, William. 1997. *The Analysis of Beauty,* edited by Ronald Paulson. New Haven.

———. 1833. *Anecdotes of William Hogarth, Written by Himself.* London.

Hopkinson, Martin. 1984. "William Hunter, William Hogarth and 'The Anatomy of the Human Gravid Uteris.'" *Burlington Magazine* 126:156–59.

William Hunter. 1774. *Anatomia Uteri Humani Gravidi Tabulis Illustrata, Auctore Gulielmo Hunter... The Anatomy of the Human Gravid Uterus Exhibited in Figures, by William Hunter...* London.

Jarrett, Derek. 1976. *England in the Age of Hogarth.* Frogmore, Great Britain.

Johnson, Captain Charles [pseud.] 1734. *A General History of the Lives and Adventures of the Most Famous Highwaymen, Murderers, Street-Robbers, &c.* London.

Johnson, Samuel. 1755. *A Dictionary of the English Language: In Which the Words are Deduced from Their Originals, and Illustrated in Their Different Significations by Examples from the Best Writers.* London.

Kermode, Jenny, and Garthine Walker. 1994. *Women, Crime and the Courts in Early Modern England.* London.

Langford, Paul. 1986. *Walpole and the Robinocracy.* The English Satirical Print, 1600–1832. Alexandria, Va.

Linebaugh, Peter. 1991. *The London Hanged.* New York.

———. 1975. "The Tyburn Riot Against the Surgeons." *In Albion's Fatal Tree: Crime and Society in Eighteenth-Century England,* edited by Douglas Hay, Peter Linebaugh, John G. Rule, E. P. Thompson, and Cal Winslow. New York.

Mandeville, Bernard. 1725. *An Enquiry into the Causes of the Frequent Executions at Tyburn: And a Proposal for Some Regulations Concerning Felons in Prison, and the Good Effects to be Expected from Them: to Which is Added a Discourse on Transportation and a Method to Render that Punishment More Effectual*. London.

Marks, Alfred. 1909. *Tyburn Tree: Its History and Annals*. London.

McLynn, Frank. 1989. *Crime and Punishment in Eighteenth-Century England*. New York.

Mead, Richard. 1720. *A Short Discourse Concerning Pestilential Contagion: And the Methods to be Used to Prevent It*. London.

Mendelson, Sara, and Patricia Crawford. 1998. *Women in Early Modern England 1550–1720*. Oxford.

Much Ado about Nothing: or, a Plain Refutation of All that has been Written or Said Concerning the Rabbit-Woman of Godalming. Being a Full and Impartial Confession from her own Mouth, and under her own Hand, of the Whole Affair, from the Beginning to the End. Now Made Publick for the General Satisfaction. 1727. London.

Naish, Camille. 1991. *Death Comes to the Maiden: Sex and Education, 1431–1933*. New York.

O'Neale, Dennis. 1754. *Memoirs of the Life and Remarkable Exploits of the Noted Dennis Neale, alias John Clark, Otherwise Called the Second Turpin; Who was Executed at Tyburn, on Monday the 4th of February, 1754, for Robbing on the Highway*. London.

Parker, Stephen. 1990. *Informal Marriage, Cohabitation and the Law 1750–1989*. New York.

Paulson, Ronald. 1970. *Hogarth's Graphic Works*. Revised edition. Vol. 1. New Haven.

———. 1971. *Hogarth: His Life, Art, and Times*. Vol. 1. New Haven.

———. 1991. *Hogarth*. Vol. 1. New Brunswick, N. J.

———. 1992. *Hogarth*. Vols. 2 and 3. New Brunswick, N. J.

———. 1995. "Emulative Consumption and Literacy. The Harlot, Moll Flanders, and Mrs. Slipslop." In *The Consumption of Culture 1600–1800: Image, Object, Text*, edited by Ann Bermingham and John Brewer. New York.

Postle, Martin. 1997. "Hogarth's Marriage à la Mode, Scene III: A Re-inspection of 'The Inspection.'" *Apollo* 146:38–39.

Rocque, John. 1981. *The A to Z of Georgian London*, edited by Ralph Hyde. Lympne Caste, Great Britain.

Sands, Mollie. 1987. *The Eighteenth-Century Pleasure Gardens of Marylebone, 1737–1777*. London.

Sawday, Jonathan. 1995. *The Body Emblazoned: Dissection and the Human Body in Renaissance Culture*. London.

Sharpe, J. A. 1986. *Crime and the Law in English Satirical Prints 1600–1832*. The English Satirical Print, 1600–1832. Alexandria, Va.

———. 1985. "'Last Dying Speeches': Religion, Ideology and Public Execution in Seventeenth-Century England." *Past & Present* 107:144–67.

Shaw, Sheila. 1995. "Spontaneous Combustion and the Sectioning of Female Bodies." *Literature and Medicine* 14.1:1–22. http://muse.jhu.edu:80/journals/literature_and_medicine/vo14.1shaw.html.

Spierenburg, Pieter. 1995. "The Body and the State: Early Modern Europe." In *The Oxford History of the Prison: The Practice of Punishment in Western Society*, edited by Norval Morris and David J. Rothman. New York.

Swanson, Gayle R. 1990. "Henry Fielding and 'A Certain Wooden Edifice' Called the Gallows." In *Executions and the British Experience from the 17th to the 20th Century: A Collection of Essays*, edited by William B. Thesing. Jefferson, N.C.

Taylor, John. 1750. *The Ordinary of Newgate's Account of the Behaviour, Confession, and Dying Words of the Ten Malefactors Who Were Executed at Tyburn on Monday the 11th of February, 1751; Being the Third Execution in the Mayorality of the Right Honble. Francis Cokayne, Esq., Lord Mayor of the City of London*. No. 3. London.

The Several Depositions of Edward Costen, Richard Stedman, John Sweetapple, Mary Peytoe, Elizabeth Mason, and Mary Costen; Relating to the Affair of Mary Toft, of Godalming in the County of Surrey, Being Deliver'd of Several Rabbits: as They were Taken before the Right Honorable the Lord Onslow, at Guildford and Clandon in the Said County, on the Third and Fourth Days of this Instant December 1726. 1727. London.

The Tyburn-Ghost, or, The Strange Downfall of the Gallows: A Most True Relation How the Famous Triple-Tree Neer Paddinton was on Tuesday-Night Last (The Third of This Instant September) Wonderfully Pluckt up by the Roots, and Demolisht by Certain Evil-Spirits: To Which is Added, Squire Ketch's Lamentation for the Loss of his Shop, &c. 1678. London.

Thompson, E. P. 1977. *Whigs and Hunters: the Origin of the Black Act*. New York.

Uglow, Jenny. 1997. *Hogarth: A Life and a World*. London.

Wind, Barry. 1997. "Hogarth's *Industry and Idleness* Reconsidered." *Print Quarterly* 14:235–51.

INDEX